Art in Context

Poussin : The Holy Family on the Steps

Art in Context

Edited by John Fleming and Hugh Honour

Each volume in this series discusses a famous painting or sculpture as both image and idea in its context – whether stylistic, technical, literary, psychological, religious, social or political. In what circumstances was it conceived and created? What did the artist hope to achieve? What means did he employ, subconscious or conscious? Did he succeed? Or how far did he succeed? His preparatory drawings and sketches often allow us some insight into the creative process and other artists' renderings of the same or similar themes help us to understand his problems and ambitions. Technique and his handling of the medium are fascinating to watch close up. And the work's impact on contemporaries and its later influence on other artists can illuminate its meaning for us today.

By focusing on these outstanding paintings and sculptures our understanding of the artist and the world in which he lived is sharpened. But since all great works of art are unique and every one presents individual problems of understanding and appreciation, the authors of these volumes emphasize whichever aspects seem most relevant. And many great masterpieces, too often and too easily accepted and dismissed because they have become familiar, are shown to contain further and deeper layers of meaning for us.

Art in Context

*Nicolas Poussin was born in 1594 near Les Andelys in Normandy, not far from Rouen.
His parents, although stemming from the bourgeoisie, were hardly more than
peasants. Nevertheless, Poussin had considerable schooling and knew Latin. His intro-
duction to painting probably came through a provincial painter, Quentin Varin,
who came to Les Andelys in 1612. Poussin then ran away to Paris, where he studied and
practised painting. In 1622–3 he attracted the attention of the Italian poet
G. B. Marino, and probably under Marino's influence set out for Rome, which he reached
in 1624. Poussin was patronized by the papal court but his altarpiece for St
Peter's (1628–9) was unsuccessful and his later works were painted for private patrons.
His fame was such that in 1640 he was commanded to return to Paris to decorate
the Louvre. His two years there were unhappy and, in 1642, he returned to Rome for good.
At this time Poussin perfected his mature, classic style in which an earlier love of
Titian was replaced by the study of Raphael and antiquity. He also developed an ideal,
sometimes heroic landscape style, exemplified by two scenes from the life of
Phocion (1648).* The Holy Family on the Steps *of 1648 crowns a long development in
which his religious paintings became increasingly geometric and iconic.
Poussin painted almost until the end of his life and died on 19 November 1665.*

The Holy Family on the Steps, *painted in oil on canvas (68·9 x 97·5 cm.), was evolved
from drawings dating to 1645–6. It was evidently completed early in 1648 for Nicolas
Hennequin, Sieur de Fresne, who was master of the Royal Hunt in France. It is now in
the National Gallery in Washington. A good replica is in Paris (private collection).*

Allen Lane

Poussin: The Holy Family on the Steps

Howard Hibbard

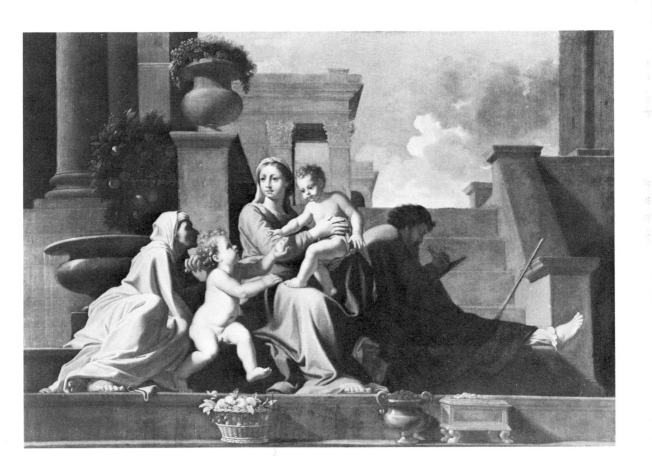

Copyright © Howard Hibbard, 1974
First published in 1974

Allen Lane
A Division of Penguin Books Ltd
21 John Street, London WC1N 2BT

ISBN *0 7139 0529 8*
Filmset in Monophoto Ehrhardt by Oliver Burridge Filmsetting Ltd, Crawley, England
Color plate reproduced and printed by Colour Reproductions Ltd, Billericay, England
Printed and bound by W. & J. Mackay Ltd, Chatham, England
Designed by Gerald Cinamon and Paul McAlinden

For Rensselaer Lee

Reference color plate at end of book

Preface

I want first to express my enormous debt to Sir Anthony Blunt, whose monograph and catalogue of Poussin's works is the basis for all further study. Even when no reference is given in the notes, the reader should still assume that more information will be found in Blunt (see Bibliographical Note, p. 92). In addition to scholarly obligations discharged by citations in the notes I want to thank some close friends who helped formulate my ideas: Alvin Labat, David Rosand, and my wife Shirley, who was an active collaborator. Milton Lewine was, as usual, my invaluable reader and critic.

At the National Gallery in Washington, the home of *The Holy Family on the Steps*, I was given every help, including free access to their files, by H. Lester Cooke. Marilyn Aronberg Lavin gave me good advice about St John the Baptist, and the Editors were particularly helpful in their critical suggestions.

I would not have written on Poussin at all without the inspiration given many years ago by Rensselaer Lee, to whom this little book is dedicated by a grateful pupil.

Scarsdale, New York
December 1971

Historical Table

1640	
1641	Protestants massacred in Ulster.
1642	English Civil War begins. Urban VIII condemns Jansen's *Augustinus* at instigation of Jesuits. Death of Richelieu.
1643	Louis XIV succeeds to throne. Spanish ascendancy in Europe ends at Battle of Rocroi.
1644	Innocent X (Pamphilj) elected Pope.
1645	Cromwell defeats royalists at Naseby. Archbishop Laud beheaded.
1646	
1647	Lutherans acknowledge Calvinists as co-religionists.
1648	Outbreak of the Fronde in France. Peace of Westphalia (condemned by Innocent X) ends Thirty Years War.
1649	Charles I beheaded.
1650	Jubilee Year in Rome.
1651	Louis XIV attains legal majority. Cardinal Mazarin in power.
1652	
1653	Cromwell Lord Protector. Pascal joins Jansenists at Port Royal. End of Fronde.
1654	Coronation of Louis XIV.
1655	Alexander VII (Chigi) elected Pope. Protestants massacred in Savoy.
1656	

Death of Rubens.
Poussin in Paris. Pietro da Cortona decorating Palazzo Pitti, Florence. Death of Van Dyck.
Rembrandt, *Night Watch*. Borromini begins S. Ivo alla Sapienza.
Death of François Duquesnoy.

Jansen, *Augustinus*. Corneille, *Polyeucte*; *Horace*; *Cinna*. 1640
Descartes, *Meditationes de Prima Philosophia*. 1641

Hobbes, *De Cive*. Death of Galileo. Monteverdi, *L'Incoronazione di Poppea*. Baglione, *Le vite de' pittori*. 1642
Joh. Bollandus, S. J., begins to edit *Acta Sanctorum*. Antoine Arnauld, *De la fréquente communion*. Evangelista Torricelli invents barometer. 1643
A. Escobar, *Liber Theologiae Moralis* (standard work of Jesuit moral theology). Milton, *Areopagitica*. Descartes, *Principia Philosophiae*. 1644
Lord Herbert of Cherbury, *De Religione Gentilium Errorumque apud eos Causis*. 1645

Mansart begins the Val-de-Grâce.
Philippe de Champaigne becomes a Jansenist.
Algardi begins *The Meeting of Leo and Attila* (St Peter's).
Bernini begins *Ecstasy of St Teresa*.
Poussin: *The Holy Family on the Steps*
Académie Royale founded in Paris.
Bernini begins Four Rivers Fountain.
Death of Louis Le Nain.
Death of Simon Vouet.
Rembrandt, *Hundred Guilder Print*.

Henry Vaughan, *Poems*. Richard Crashaw, *Steps to the Temple*. Birth of Leibnitz. 1646
Corneille, *Rodogune*. Luigi Rossi, *Orfeo*. 1647
Herrick, *Hesperides*. Cyrano de Bergerac begins *Histoire comique des états de la lune*. Descartes, *Description du corps humain* (published 1672). 1648

Richard Baxter, *The Saints' Everlasting Rest* (devotional book of Independents). Gassendi, *Philosophiae Epicuri Syntagma*. P. F. Cavalli, *Giasone*. 1649

Velázquez in Rome, paints Innocent X.
Borromini completes Oratorio di S. Filippo Neri.
Cortona begins decoration of Galleria Pamphilj.

Milton, *Pro Populo Anglicano Defensio*. Bosio, *Roma sotterranea*. Carissimi, *Jephtha*. Death of Descartes. 1650
Hobbes, *Leviathan*. Harvey, *Exercitationes de Generatione Animalium*. 1651

Le Pautre begins the Hôtel de Beauvais, Paris.

1652
Mlle de Scudéry, *Le grand Cyrus*. 1653

Death of Alessandro Algardi.

Cyrano de Bergerac, *Le pédant joué*. 1654

Velázquez, *Las Meninas*. Bernini begins piazza at St Peter's.
Cortona begins remodeling S. Maria della Pace. First dated painting by Vermeer, *The Procuress*.
Birth of Fischer von Erlach.

Pascal begins *Les lettres provinciales* against Jesuits. 1656

Introduction

The Holy Family on the Steps is a distillation of Poussin's mature, deeply considered art.[1] It ostensibly shows the Holy Family visited by the child John the Baptist and his mother Elizabeth, all of whom are placed on a flight of steps in a group of unusual unity – geometric, spatial, and psychological. The picture is as perfect and as cool as a proposition from Euclid. Our eyes perceive the perspective and other geometrical and mathematical relationships in the constructed space: mathematics and perspective were subjects dear to Poussin. Still, he seems to have purposely telescoped recessional features such as the steps, in order to accentuate the foreground composition and keep our awareness of the picture plane.[2] The viewpoint is so low that neither the steps nor the foreshortened antique buildings in the background serve to create a deep space; the central vanishing point is deep within the picture, bringing the eye forward again to the figures. The result is a densely rich interplay between the surface of the painted canvas and the fictive space, which consists of a relatively planar figural composition set before a background where powerful recession is held in check. The whole picture works together as a basically geometric composition in which pseudo-human figures are like elements in a construction that carries outward and back into more properly architectural forms with galvanic unity and arresting artificiality. The dream-like, almost surreal perfection of the painting is unique.

We would miss the point of any painting by Poussin if we considered the style apart from the content. *The Holy Family on the Steps* is an iconic religious picture that conveys explicit meaning

along with more subtle, possibly even hidden ideas that make it one of the great images of its time. The aim of my essay is to present this *Holy Family* as a beautiful and meaningful work of art. The picture is also part of Poussin's evolving artistic vision and must be considered first in the context of his career.

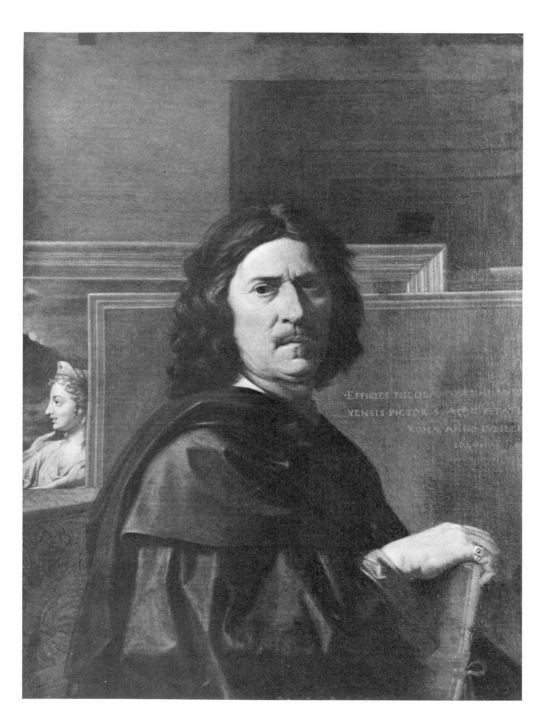

1. Poussin and Rome

1 (opposite). *Self-Portrait*, 1649–50. Poussin

2. *Self-Portrait*, c. 1630. Poussin

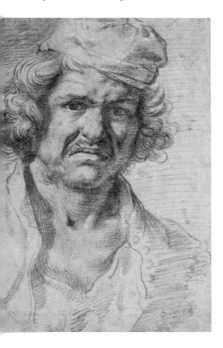

Nicolas Poussin was fifty-four and at the height of his abilities when he painted *The Holy Family on the Steps* [see color plate at end of book]. He was a well-known and revered figure in Rome where he had been living for almost a quarter of a century and was generally recognized as the greatest living French artist. Indeed, he had just recently been appointed *Premier Peintre du Roi* by Louis XIII. We see him, through his own eyes, at this high point in his career in the well-known self-portrait now in the Louvre [1], painted a year after he had finished *The Holy Family on the Steps*. Clearly, he was fully aware of his own distinction – intellectual as well as artistic. And it was during this central decade of his life, the 1640s, that he had created some of the noblest of his heroic landscapes as well as several religious paintings of very elevated feeling. But in the late forties his style began to change, veering towards a kind of hyper-classicism – an almost frozen or geometric style – culminating in a great series of Sacraments of 1644–8 painted for his friend and patron Chantelou [15, 16]. These hauntingly austere works, on which he was working at the same time as he conceived and began *The Holy Family on the Steps*, seem to mark a turning-point in his artistic career. But in order to understand how he reached this high ground we must go back to his beginnings, to the farouche young painter [2] who was so very different from the withdrawn and scholarly artist he became in middle-age.

The facts of Poussin's early life can be quickly stated. He was born in Normandy in 1594, went to Paris at about the age of eighteen, and remained in France for another decade – yet both his artistic style and his successful career were essentially formed and

developed in Rome. His early years in France were spent as a rising practitioner of what was essentially a provincial style, but almost nothing survives from this long apprenticeship. He was clearly dissatisfied with the opportunities available in his own country, and he made two abortive attempts to journey to Rome; on one of them he actually got as far as Florence before turning back. Finally, encouraged by the Italian poet Giambattista Marino, whom he had met and served in Paris, Poussin made his way to Venice and finally to Rome in the spring of 1624. Marino died the following year, leaving Poussin with few friends, no influence, and little to offer the dazzling court of Urban VIII (1623-44), the ambitious Barberini Pope. The grand master of the Barberini artistic enterprises was the precocious, facile, and overbearing genius Gianlorenzo Bernini (1598-1680), whom Urban wanted to mold into a new Michelangelo, equally triumphant in the arts of sculpture, painting, and architecture.[3] To this end Bernini, who had already revolutionized the art of marble portraiture and statuary, was given commissions of ever-increasing magnitude - the rebuilding of an Early Christian church (S. Bibiana) and the construction of a new, monumental decoration over the grave of St Peter, the baldachin [4]. By the later 1620s he had been given total control of the completion and decoration of St Peter's and the prestigious title of Architect of the Church. Bernini, however, did not become much more than an amateur painter, and Roman painting of the 1620s was somewhat less spectacular than Bernini's novel statuary. The history of Roman Baroque painting is nevertheless the story of large-scale decorative enterprises. Perhaps the leading stylistic current of the mid-1620s is represented by Giovanni Lanfranco of Parma, whose dome fresco in Sant'Andrea della Valle in Rome (1625-8) exhibits renewed study of Correggio, the great decorator of Parma in the preceding century. The dynamic, spatial style of Lanfranco was also indebted to Venetian painting; Lanfranco's paintings have analogies in Bernini's exuberant statuary [3, 4], and these new styles infected

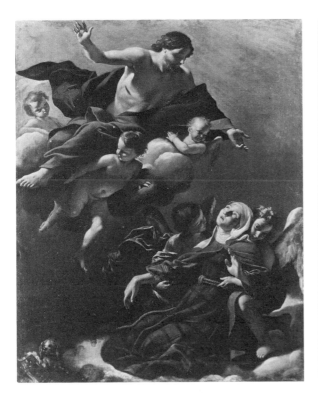

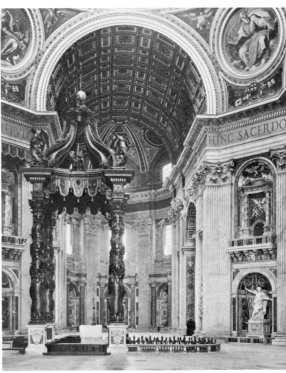

3 (left). *St Margaret of Cortona*,
1621. Lanfranco

4 (right). St Peter's: the baldachin,
1624–33, and St Longinus, 1629–38.
Bernini

even fairly resistant, classicizing artists like Domenichino and
Poussin.

By contrast with the favorites, Poussin had at first to struggle
along as one of a large colony of foreign artists. He must have cut a
fine figure since he was tall, well-built, with an olive complexion
and sky-blue eyes. Although Poussin remained in some ways French
all his life, his manner of deportment changed abruptly soon after
his arrival when – anti-French feeling running high – he was at-
tacked in the street because of his French dress by a group of angry
Romans; he escaped serious injury only thanks to a sheaf of draw-
ings with which he absorbed the blows. After this he decided to do
as the Romans, and we are told that he learned to speak Italian like
a native. He studied anatomy, geometry, and perspective. He drew

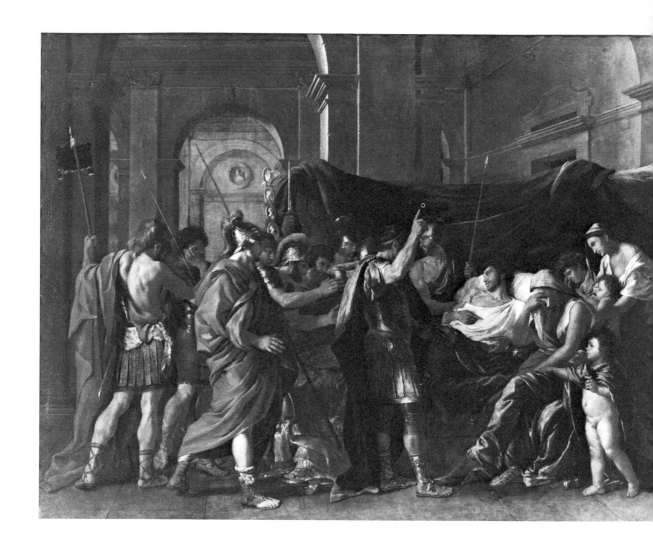

5. *The Death of Germanicus*, 1627. Poussin

from live models in the studio of Domenichino, one of the more conservative painters of the time and a favorite of Poussin's. We would normally expect a painter of thirty to be fully formed, but Poussin was the slowest of the great seventeenth-century masters to develop – the very antithesis of Van Dyck or Bernini – and his first Roman paintings are somewhat crude and fumbling. Nevertheless, by 1627 Giulio Mancini, the Pope's private physician who had an avid interest in contemporary art, mentioned Poussin in his manuscript book on painting, noting that he had studied Latin – Poussin's erudition was obviously unusual among painters.[4] The reason for Mancini's notice of this rather obscure foreigner derives from the fact that Francesco Barberini, the influential cardinal-nephew of Urban VIII, had returned from an extended diplomatic mission to Spain in December of 1626. Poussin evidently had a letter of introduction from the poet Marino, and Barberini immediately commissioned a picture. In the following year Poussin painted a second picture on commission from Barberini that is his first wholly successful work, *The Death of Germanicus* [5]. This noble painting shows how Roman an artist he had become in a little over three years (cf. p. 27). The achievement manifest in the *Germanicus* led to a public commission in 1628, an altarpiece for St Peter's representing the horrible martyrdom of St Erasmus [6]. The picture, however, was not received with universal acclaim; the public preferred its less distinguished pendant by Valentin, a follower of Caravaggio, and Poussin never again painted an altarpiece in Rome. As an indirect result he was eventually able to become the most individual and independent of the great Catholic artists. Totally unlike Rubens, Bernini, or Velázquez, Poussin was free from courtly ties. Although most of his paintings were commissioned, they reflect his own interests and taste to a marked degree. In this sense he resembles his great Protestant contemporary in Holland, Rembrandt.

Late in the 1620s Poussin became ill, evidently with syphilis; he was nursed back to health by the family of Jacques Dughet, a

friendly French cook. An unusual self-portrait drawing, of startling realism, dates from this time [2].[5] Upon his recovery, Poussin married Dughet's seventeen-year-old daughter, Anne-Marie. Dughet's sons were also artists and apprenticed themselves to Poussin; Gaspard, who later adopted the name Poussin, became an outstanding master of poetic landscape. It seems clear that many of Poussin's friends were compatriots and that his Italian acquaintances were artistically conservative – or perhaps, more accurately, were in some sense members of the anti-Bernini faction. In the mid-1620s Poussin shared a house with the gifted Flemish sculptor François Duquesnoy; Duquesnoy later made a terra-cotta bust of Mme Poussin (now lost). One of Poussin's enduring acquaintanceships – it may not have been more than that – was with the landscape painter Claude Lorraine (1600–82). After Domenichino left Rome for Naples in 1631 Poussin drew from the live model in the studio of Andrea Sacchi, an artist who had begun his career in the 1620s as an innovative comet but soon afterwards fizzled out. We must never forget the importance of this kind of life-drawing for all artists of the time. Poussin not only drew from the formally posed model, 'he was always studying wherever he might be. When he walked in the streets he observed the actions of all those he met, and if he saw one which seemed to him of interest, he noted it in a book which he always carried with him for this purpose.'[6]

After the relative failure of the *Erasmus*, Poussin quickly found his niche as a painter of medium-sized, usually horizontal, figural compositions for the collections of understanding *amateurs*. At first these patrons were chiefly Italian. Cassiano dal Pozzo, whose 'museum' of drawings after the antique was available to the studious Poussin, collected some fifty of his pictures, chiefly in the 1630s and 1640s. Poussin's knowledge of antique art and thought matured under the guidance of dal Pozzo's library and collection. Among these treasures was a manuscript of Leonardo da Vinci's *Treatise on Painting*, for which Poussin drew figural illustrations that were later published. Thanks to such tutelage, he grew into an impressive

artistic personality capable of expressing different emotions and ideas through his paintings.

Some of Poussin's pictures found their way to Paris, where they made such an impression that in 1639 he received an official invitation from Richelieu to enter the service of Louis XIII. Poussin delayed for a year, but finally, in mid-1640, he was more or less commanded to come because he was still a citizen of France. He arrived in December, accompanied by Paul Fréart, Sieur de Chantelou, who became one of his closest friends and greatest patrons. Poussin was immediately employed on a large-scale decoration for the vault of a long gallery in the Louvre, a project for which he was unprepared and unsuited. After his first enthusiastic reception he began to experience the jealousy and intrigue of the French artists and the fickleness of the court. Soon he was comparing the trip from Rome to Paris with a journey direct from Paradise to Hell, and his sharp tongue could hardly have increased his popularity with the artists of the court. Poussin 'is a man who lives for Italy' a friend wrote to Cassiano dal Pozzo in 1642.[7] Late that year Poussin slipped away with the excuse that he had to close up his house in Rome and bring back his wife, whom he had carefully left behind. Once in Rome, he stayed. That he was allowed to stay was partly fortuitous: Richelieu died late in 1642 and Louis XIII, a discerning patron of the arts, the following year. The new minister, Mazarin, had mounting troubles that culminated in the horrors of the Fronde in 1648. Little wonder that Poussin was more or less forgotten. He hated Mazarin and loved the quiet life in Rome; and the increasing disruption of life in Paris filled Poussin with alarm. 'My nature leads me to seek out and love things that are well-ordered, fleeing the confusion that is as foreign and hostile to me as is the light to deepest darkness,' he had written to Chantelou from Paris in 1642.

Poussin's Parisian acquaintances henceforth furnished him with an essentially French clientèle; among them was his dear friend

Chantelou, who built a great collection. Poussin's visit to France, his appointment as *Premier Peintre du Roi* and other honors, put him in a new category. He must have felt a new sense of worth, a new awareness and pride in being French and the best French painter. In a defensive letter of 1645 he refers to himself as 'un vertueux connu de toute l'Europe'. A general gravity and nobility pervade most of his work of the 1640s. From this period we have a fascinating set of letters from which we can learn much about his thought. Deep study and carefully cultivated companions had turned a country boy into a learned, philosophical interpreter of ancient myth and history. This is the somewhat self-important Poussin familiar to us from his famous self-portrait of 1649–50 [1]. There we see the pensive *peintre-philosophe* who walked nobly through the Piazza di Spagna and on the Pincio, morning and evening, surrounded by admirers who listened for his every grave, slow word on artistic theory and decorum. The emblem representing Painting on the left-hand side of the *Self-Portrait* combines outstretched arms of friendship (the picture was for Chantelou) and a diadem with an eye, symbolizing perspective as the rational, intellectual aspect of the profession. This is the Poussin who could explain, when asked how he had achieved his position of artistic eminence, 'Je n'ai rien négligé.'[8] Since the early *Self-Portrait* of *c.* 1630, Poussin's self-image had probably changed more than his actual features had altered [2]. He did, however, suffer from numerous illnesses and creeping old age; in 1643, when he was forty-nine or fifty, we first hear him complain about the 'trembling hand' which so plagued him in his last years that he could hardly write or paint.

Poussin's fame spread to such a degree that at the end of his life he was internationally revered. The Duc de Chevreuse, before leaving Rome in the spring of 1664, expressed an understandable national pride in the great artist and wanted to visit the man he considered to be 'the most illustrious painter of all times, equalling Raphael in drawing (*dessin*) and surpassing him in history and com-

position (*ordonnance*)'.[9] Perhaps the most unexpected tribute to Poussin finally came from the artist who represents his stylistic and personal opposite, Gianlorenzo Bernini. In 1665 Bernini was in Paris, to build a new Louvre palace and to portray the King, Louis XIV. Chantelou again served as guide; his memorable diary of Bernini's visit, which is probably the most revealing single artistic document of the entire century, tells of Bernini's reaction upon seeing the great collection of paintings by Poussin in Chantelou's house. After looking long and hard at a number of them, saying little, Bernini turned to his host and said: 'Today you have given me great displeasure by showing me the worth of a man who makes me realize that I know nothing.'[10] Despite the rhetoric of this statement, Bernini was deeply impressed by the variety and profundity of the paintings, calling Poussin a 'great history painter, and a great painter of mythology'. On another occasion, while looking at one of the Phocion landscapes [14], he turned to his companion and said, pointing to his brow: 'M. Poussin is a painter who works up here.'

By the 1660s, however, Poussin had aged greatly; he had all but ceased painting and lived more than ever like a stoic philosopher. After the death of his wife late in 1664 the childless artist gave away most of his belongings to her relations. Profoundly depressed, he felt old, French, and alone in the Rome he had loved. A month after Anne-Marie's death he wrote to Chantelou: ' . . . When I needed her most she left me, full of years, paralytic, wracked by all kinds of infirmities, a stranger and without friends . . . ' This was not quite true. The painter-agent Abraham Bruegel wrote on 22 May 1665 to the collector Don Antonio Ruffo: 'le seigneur Poussin does nothing, apart from taking an occasional little glass of wine with my neighbor Claude Lorrain; and last evening we drank your health . . . '[11] The words of Jean Dughet apprising Chantelou of Poussin's death six months later must have expressed the sentiments of many: 'Your Highness has doubtless heard of the death of the famous M. Poussin, or rather, of painting itself.'

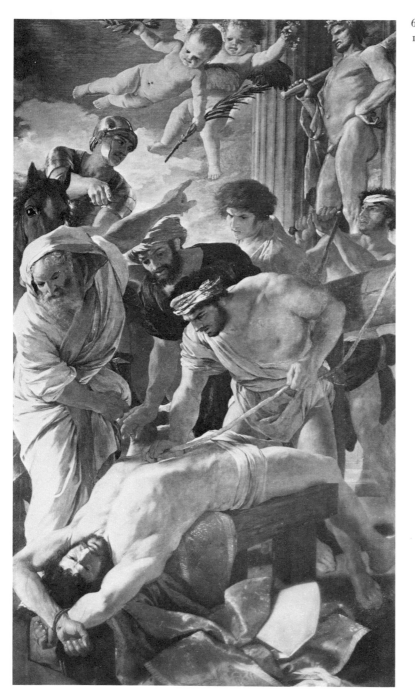

6. *The Martyrdom of St Erasmus*, 1628–9. Poussin

POUSSIN'S EARLIER STYLE

In retrospect, Poussin is indeed the great French painter of the age because other Frenchmen took his paintings as a hallmark of excellence and made them the foundation of a new French style. Nevertheless, the claim that his own painting is French must be considerably modified. Still a fumbling provincial when he arrived in Rome in 1624, Poussin evolved his style as we know it from Roman art of the 1620s and 1630s. Until the trip to France in 1640-42 his patrons were chiefly Italian and he was still a participant in local artistic currents – although less and less as time went on. After his return, his art takes its own course, with no visible reference to contemporary Roman painting. The Spaniard Picasso, all his mature life a resident of France, is a modern parallel. Neither artist can easily be typed by nationality; each was a leader in the art of his time while remaining independent and autonomous.

Unlike Simon Vouet, the French master who had preceded him to Rome, Poussin from the beginning avoided a realistic or genre approach to subject matter. At first he made himself into what appears to be a perfectly acceptable facsimile of a Roman painter. His *Death of Germanicus* [5] and especially *The Martyrdom of St Erasmus*, for St Peter's, were as much in the current style as the contemporary paintings of Pietro da Cortona, Andrea Sacchi, or Giovanni Lanfranco – and, to our eyes, just as good. Poussin must have been pushed inescapably in the direction that led to the unsuccessful *Erasmus*, which exhibits dramatic movement on a shallow stage with complex diagonal recession, painted in light tonalities of rich, realistic color. (Even the conservative Domenichino had been drawn into a Baroque current in the mid-1620s when he found himself competing with Lanfranco in Sant'Andrea della Valle.) On the other hand, Poussin was also attracted by classical antiquity. It is a shock to some of our preconceptions of Baroque painting in Rome to compare Poussin's *Germanicus* with a roughly contemporary picture by Pietro da Cortona, who became the greatest of the Italian

Baroque decorators [7]. In the 1620s, both men often painted themes
from antiquity and followed the planar compositions found in an-
cient reliefs, which both artists had studied and copied with care.[12]

Poussin's style was formed on the basis of hard study of the works
of art that have always drawn artists and connoisseurs to Rome : the

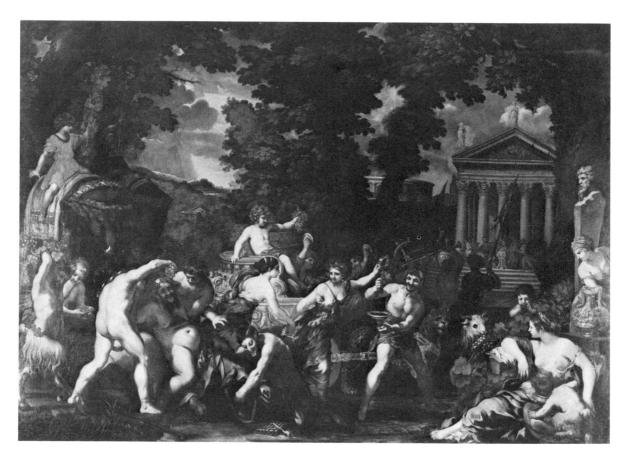

sculptures of antiquity and the paintings of Raphael and Michel-
angelo – what we loosely call classic art, ancient and Renaissance.
But the most alluring influence of these years, the unifying inspi-
ration of much Roman painting of the 1620s, was a new vision of
the art of Venice. This was in part provided by Titian's famous
Este *Bacchanals* [8]. They had been brought to Rome from Ferrara

7. *The Triumph of Bacchus, c.* 1623.
Pietro da Cortona

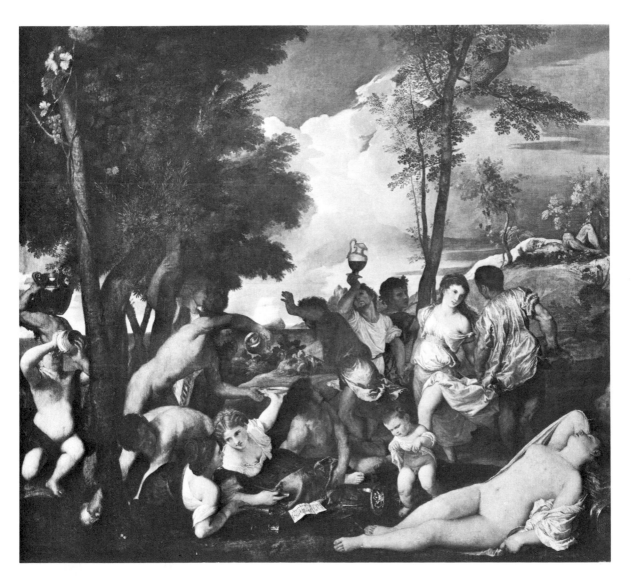

8. *Bacchanal: The Andrians*, 1519.
Titian

around 1600 by one papal nephew, Cardinal Pietro Aldobrandini, and in Poussin's time two of the pictures had been acquired by another cardinal-nephew, Ludovico Ludovisi. Poussin knew, and was influenced by, all of them.[13]

Poussin's neo-Venetian style blossomed in the years around 1630 in such memorable idylls as *The Arcadian Shepherds*, *The Nurture*

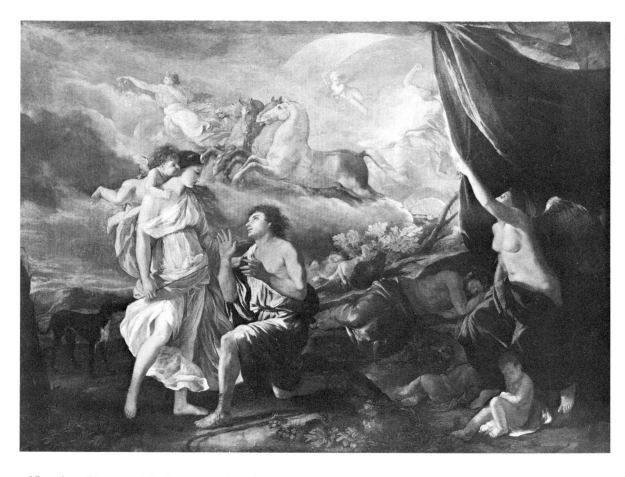

of Bacchus, Diana and Endymion, and various satyric scenes [9, 10].
These paintings are soaked in the golden light of Titian and are
peopled with an Arcadian cast of handsome and amorous nymphs,
gods, and *putti* – like the Lotos-Eaters – 'propt on beds of amaranth
and moly'. The coloristic sensuousness of Poussin's pictures was
noticed as early as 1627 by Giulio Mancini, who stressed Poussin's
saturation in the Venetian school of painting. Poussin's Venetian
paintings also have a barely disguised sensuality of subject and
treatment. Still, there is almost always a pall of something like fate
hanging over these gracious or lascivious spirits – a melancholy
sense of time running out that is explicit in such subjects as Diana

9. *Diana and Endymion,*
c. 1632. Poussin

10 *(opposite). The Arcadian Shepherds,*
c. 1630. Poussin

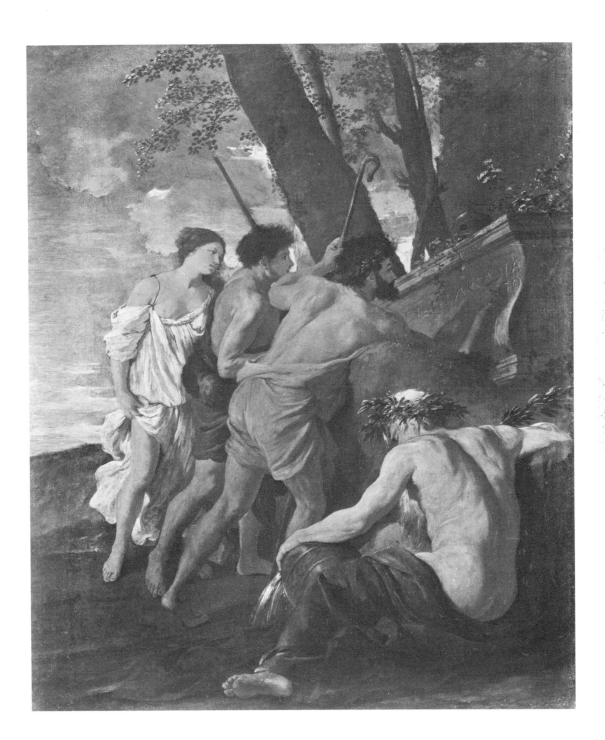

and Endymion, Cephalus and Aurora, or Venus and Adonis. Even after he had given up Venetian things as pretty baubles, unworthy of the seriousness of his artistic enterprise, Poussin expressed his sense of cycle, of inevitable decay, in *A Dance to the Music of Time*, in which the brief course of the days and years is clearly shown [11]. The pleasures of the moment are but bubbles, and man's life runs its course, not only from birth to death, but also cyclically: mankind emerges from poverty through labor, eventually attains riches, then luxury – then loses all to begin once more in poverty.[14] A more poetic statement of the same kind is found in the earlier

11. *A Dance to the Music of Time,*
c. 1639. Poussin

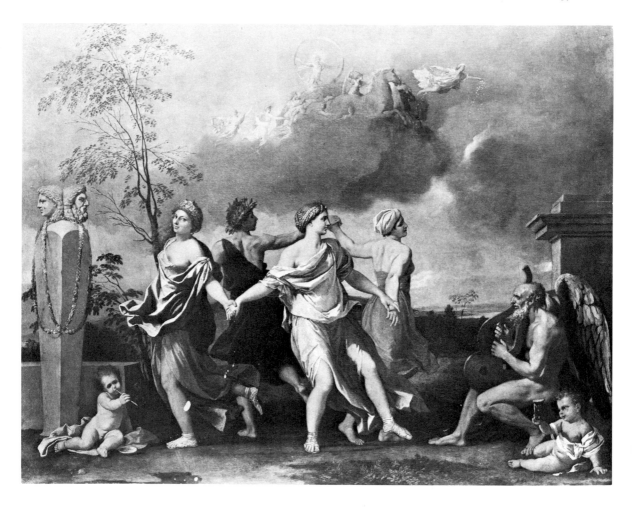

pictures of Arcadian shepherds who try to read the inscription on a gravestone: ET IN ARCADIA EGO – Death is even in Arcadia [10].[15]

Poussin's Venetian phase – poetic, charmed, and like some romantic heroine, doomed to short life – begins among other artistic currents, classic and Baroque. One of the characteristics of Poussin's style is his continual mixture of manners, probably born of a desire to deal appropriately with very different types of subject matter by calling on varied traditions. This sounds like an eclectic process, and in that sense all seventeenth-century artists were to some degree eclectics, recalling at will their rich heritage of antique and Renaissance models (cf. p. 49ff. below). Poussin was particularly sensitive to the requirements of different subjects, an example of his interest in what the seventeenth century called 'decorum'. He was careful to 'suit the action to the word', which is to say that he selected gestures and costumes to correspond to the sense and historical context of the subject. At a later date he quoted an elaborate theory of Greek musical 'Modes' as an analogy to the different styles of his pictures.[16]

By the later 1630s Poussin had turned most explicitly to Raphael as his chief modern source of inspiration, giving up sensuous color and texture in favor of an intellectual, historical, and moral approach to painting that sometimes results in compositions devoid of surface charm or coloristic interest. Poussin expressed part of his philosophy of art in the letter on the Modes of 1647, in which he states:

' . . . We must not judge by our senses alone but by reason . . .

'Those fine old Greeks, who invented everything that is beautiful, found several Modes by means of which they produced marvellous effects.

'This word Mode means, properly, the *ratio* or the measure and the form that we employ to do anything, which compels us not to go beyond it, making us work in all things with a certain middle course or moderation. And so this mediocrity or moderation is simply a certain manner or determined and fixed order in the process by which a thing preserves its being.'[17]

How rational such a statement is, how different from the Romantic cult of inspiration and personality! These particular sentiments may have been bolstered by a liberal group of neo-Stoics whom Poussin met in Paris during 1641-2.[18] In the following years a number of his subjects (e.g., the Phocion landscapes [13, 14]) attest to his meditated fascination with Stoic themes. His impatience with mere realism, and with the attractive but shallow productions of his Italian contemporaries, is reflected in a statement made to his biographer Félibien when the latter knew Poussin in Rome (1647-9): 'A painter is not a great painter if he does no more than imitate what he sees, any more than a poet. Some are born with an instinct like that of animals which leads them to copy easily what they see . . . But able artists work with their minds . . .'[19] Nevertheless, Poussin never entirely ceased being a painter in the Venetian sense of the word. The works that seem to represent the highest level of his genius unite his learning and intellectual control with something that can be called, simply, art. Poussin's ability to control his inspiration and to subordinate coloristic handling and sensibility to intellectual and moral purposes is however manifest in his mature style. This is the quality of Poussin's art that Bernini instinctively recognized. It is the aspect that interests us now.

PICTURES OF THE 1640S

Poussin's neo-Venetian pictures will always have fervent admirers; they are his most accessible and attractive works. His late paintings, often strange and poetic, have a devoted but more limited following. The pictures of the 1640s, however, can claim to be his most enduring and characteristic. They are of various subjects and styles. Paradoxically, it is only in this 'classic' period that he turned his attention wholeheartedly to landscape. Landscape, according to contemporary artistic theory, was far lower in status than history painting. Landscape was thus in no sense classic in any of the usual meanings of the word. During the 1640s and 1650s, however,

Poussin raised this lowly and popular art to the intellectual and moral level of his other works. Some of his earlier landscapes are hardly more than remembered views of specific places in the Roman Campagna, where he sometimes sketched in the company of Claude, that denizen of the countryside.[20] Other landscapes by Poussin present a more ordered, rationalized vision that is in some sense an extension of a figural subject in the foreground. Such a picture is the landscape with St John the Evangelist [12]. The carefully ordered classical ruins, overgrown with trees and foliage, seem to comment on the mystic Revelation that John is writing. In many historical and

12. *St John on Patmos, c.* 1644–5. Poussin

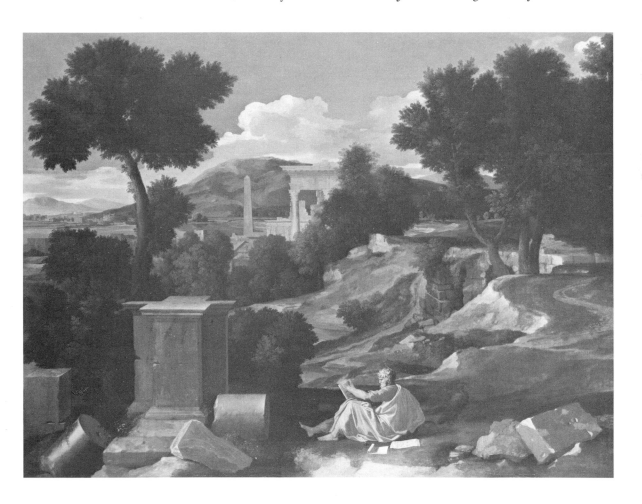

even in some of the devotional pictures of this period and later, Poussin used landscape as an extension of the figural composition [43, 56].

The greatest of Poussin's heroic landscapes date from 1648, the year of *The Holy Family on the Steps.* They show the body of the unjustly executed Athenian general Phocion carried into Megara, and the recovery there of his ashes by his widow [13, 14]. Only full knowledge of the subject, whose life is given by Plutarch, can illuminate the meaning of these two overwhelming pictures, which have been called commentaries on the Stoic theme of constancy.[21] But even a cursory glance can differentiate the relatively discursive and idyllic scene of *Transportation* from the frozen, ominous ordering of architecture and nature in the *Ashes.* In the latter, man appears as

13. *The Body of Phocion,* 1648. Poussin

'a stranger and afraid in a world he never made'; this Stoic pessimism increases in some of Poussin's later canvases.

Even greater variety can be found among the more traditional historical paintings of the 1640s, but they too exhibit a heightened rhetorical classicism that Poussin's friend and biographer Giovanni Pietro Bellori called his *maniera magnifica*. In some of these paintings of the later 1640s there may be – indeed I am convinced that there actually is – a crisis, a kind of hyper-classicism. We find it developing in the later 1630s and increasing in the 1640s. After the extreme stylistic statements of 1647–8 it begins to dissipate as Poussin explored new problems and new solutions. The development of this almost frozen or geometric style is found most clearly among the seven pictures painted for Chantelou representing the Sacraments

14. *The Ashes of Phocion*, 1648. Poussin

[15, 16].[22] The Christian sacraments were an unusual artistic subject, but Poussin had actually painted a previous set of seven for Cassiano dal Pozzo. When Chantelou asked for copies of this set, Poussin proposed a new, revised series. Very possibly he welcomed the idea, for, as we shall see, his customary working procedure often resulted in different or variant compositional and iconographic ideas during the process of preparing a painting (see p. 72). He was usually left with a series of attractive alternatives, all but one of which had to be at least temporarily abandoned once he began to paint. Little wonder that he painted certain subjects many times; the Holy Family is a prime example.

The Chantelou *Sacraments* were painted between 1644 and 1648. Two of the scenes, *Baptism* and *Ordination*, find a natural setting

15. *Eucharist*, 1647. Poussin

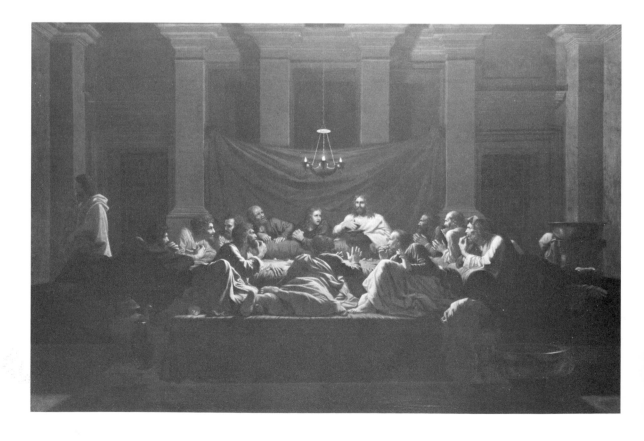

outdoors. The others are set indoors, and among them are some of the most austere pictures ever painted. *Eucharist*, of 1647, is outstanding. It illustrates the scene described by Paul (I Corinthians xi, 24-6), but Poussin has shown it unconventionally, with the Apostles reclining on triclinia after the antique manner [15].[23] Illuminated only by an antique lamp that may symbolize the Trinity, and depicted from a low point of view, the circle of intense faces and gestures becomes a central strip of light and color within the still room. The planarity of the group and the serenity of the sober architecture is oppressive, alleviated only by slight deviations from symmetry, Jesus and the departing Judas, both clothed in red. This is the period of Poussin's most hieratic compositions; after the hushed *Eucharist* came the formal and antique *Marriage* [16] of

16. *Marriage*, 1647-8. Poussin

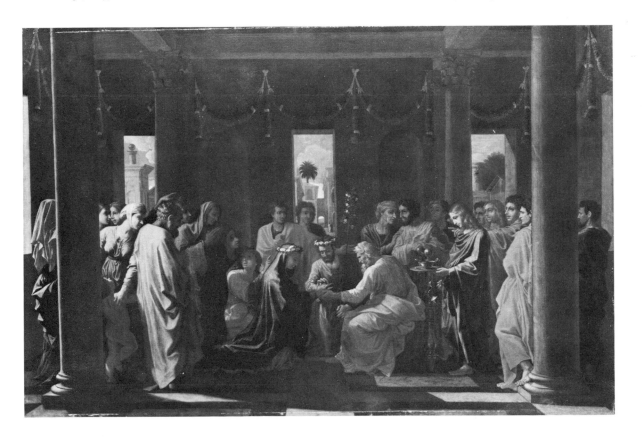

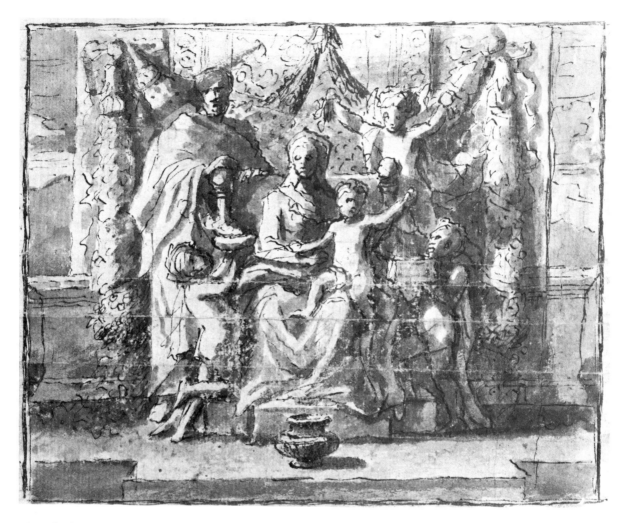

1647–8, the grand Phocion landscapes of 1648, and an incredible drawing for a neo-Venetian enthroned Madonna that is also a Holy Family [17]. Pictures such as these remind us of Sir Joshua Reynolds's famous characterization of Poussin to the Royal Academy in 1788 as 'a mind thrown back two thousand years, and as it were naturalized in antiquity'.[24]

Poussin's Holy Families stand apart from the heroic landscapes and the history paintings alike. In all, he produced a dozen versions of

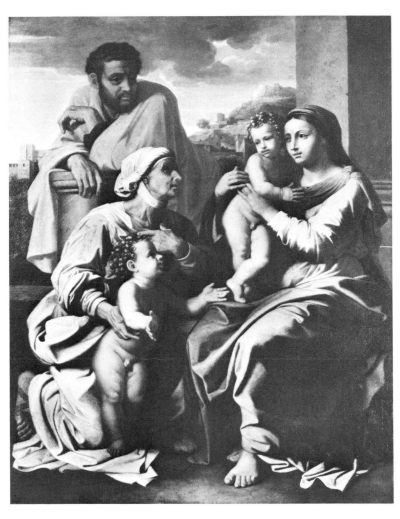

17 (*opposite*). *Madonna Enthroned with Joseph and Angels*, 1647-9. Poussin

18. *The Holy Family*, 1653-5. Poussin

the subject, of which our picture of 1648 is arguably the greatest. Some of the later pictures, however, are only partially successful [18]; and, as Friedlaender noted, 'are almost terrifyingly harsh and stiff'.[25] It seems odd that Poussin should have painted so many versions of a subject that excluded so much of his talent. Various explanations are possible, among them the great popularity of the subject and his patrons' desire for devotional images. Poussin, as we have seen, considered different demands a challenge, and he was therefore eager to vary his subject matter. 'I am not one of those who

always sings the same note', he wrote to Chantelou in 1647. With his increased fascination by the High Renaissance he may have found it challenging to produce variants on one of the favored compositions of that exalted time. He may also have had some underlying and indecipherable psychological predilection for these themes, which, all but unknown in his *oeuvre* before 1640, grew into a favorite of his middle age. We have seen that Poussin's earlier paintings are full of bittersweet erotic subjects. In the later 1630s these are interwoven with, and then wholly succeeded by other themes, many of which have to do with time, its vicissitudes, and its inevitable victory over all human affairs (see p. 32 and illustrations 10 and 11). Poussin was probably a happily married man, although we know little about his personal life, and evidently he had been in some sense an amorous one; yet he produced no children. It is not beyond possibility that Poussin's many family groups of the 1640s and 1650s are, among other things, a sublimation of his own frustrated fatherhood.

2. Poussin and Religion

The Holy Family on the Steps appears to be a strange mixture of devotional icon and formal, proportional exercise; of symbols and potential symbols; of mystery amid seeming clarity. In front of this image we immediately ask ourselves how religious a man Poussin was, and what kind of symbolism we can expect to find in his pictures. The second question will be approached in Chapter 4; the first can be discussed now.

While he was in Paris, Poussin occasionally associated with medical men, philosophers, and free-thinkers. It is tempting in the twentieth century to imagine that he was, like many of us, a religious sceptic. Poussin's paintings and correspondence are redolent with antique, especially Stoic philosophy. Many of his religious pictures, nevertheless, seem to be more than historical exercises; some appear to be genuine acts of devotion. Still, we are entitled to ask for more information before we agree to call Poussin a deeply religious man.[26]

The seventeenth century was a time of great religious ferment. In many places 'rationalism penetrated to the very heart of religious thought, bringing the formulation of an explicit rational religion'.[27] This indeed may well have been Poussin's position. There was also a growing trend toward deism and even atheism among many serious men in both Protestant and Catholic countries. A Frenchman like Poussin must have felt sympathetic, at the very least, to the 'Gallican' tendencies of the French Church, which did not always follow the dictates of Rome. France was also the home of those devout reformers, Francis de Sales (1567–1622) and Vincent de Paul (1580–1660), who stood for a deeper revival of Catholic piety and charity than was evident in the more Jesuitical thought of the

papal court. Francis de Sales thought that Christian inspiration must go beyond Christian institutions, a subtly anti-papal philosophy. These men protested against the growing luxury of the lives of the rich – and Poussin, who lived a life of frugal simplicity, obviously shared this sentiment. One evening, after receiving his friend Cardinal Camillo Massimi in his house, Poussin himself carried the candle to light the great man to the door. The cardinal said he was upset to discover that the painter did not have a single servant to do this work; Poussin replied, 'And I pity your Eminence for having so many.'[28]

Although opposed to what seemed to be the theological laxity and worldly casuistry of the omnipresent Jesuits, the French reformers nevertheless considered the Church and the Sacraments to be essential. Chief among the growing anti-Jesuit factions were the Jansenists, who took their name from a bishop of Ypres, Cornelius Jansen (1585–1638), who almost Calvinistically insisted upon a deterministic predestination. Jansen's posthumous *Augustinus*, published in 1640, was condemned by the Pope as early as 1642, but many of his beliefs found a ready audience. He appealed to those who preferred a national religious autonomy instead of Roman direction, a belief in a certain kind of predestined grace, and a stern morality that despised the easy absolution advocated and practised by the Jesuits. Jansen's followers were particularly numerous in France; beginning around 1635, they were centered in the Parisian convent of Port Royal. Poussin must surely have come into frequent contact with Jansen's ideas and advocates. Although repudiated by various papal Bulls of the 1640s and 1650s, Jansenism continued to be a force in French religious rationalism for years – we need think only of the great Blaise Pascal.

On the face of it, it seems unlikely that Poussin was himself a Jansenist. True, he had notable resignation when confronted with the inevitability of Fate; but when he wrote to Chantelou that 'one must attain true virtue and wisdom in order to stand firm and remain unmoved before the assaults of mad blind fortune', he was express-

ing a Stoic rather than a Christian philosophy.[29] He could also write that 'one must accept the will of God, who orders things thus, and fate wills that they should happen in this way'. Whether this is merely a manner of speech, or whether instead it signifies a real sense of bowing before the will of God, is very hard to say. In 1641 Poussin painted a large altarpiece for the church of the Jesuit Novitiate in Paris, and had no scruples whatsoever in doing so, to judge from the matter-of-fact tone of his letters referring to the commission and his search for a subject – which he found in *The Miracle of St Francis Xavier*. This would hardly seem to be the work of a potential Jansenist. Still, Poussin was probably influenced by their beliefs and desires for reform. The Jansenists 'believed that ever since the time of the Fathers, the Church had left the true path of theology'.[30] This idea, which had been one of the main Counter-Reformatory currents throughout the Church, might help to explain Poussin's usual avoidance of currently popular Catholic devotional imagery. The religious subjects Poussin did choose to paint were often arcane stories of Moses from the Old Testament, scenes of salvation that prefigure Christian Sacraments, and especially subjects that refer to baptism.[31] The second set of Sacraments could even have been influenced by the popular anti-Jesuit book by the Jansenist Antoine Arnauld, *De la fréquente communion*, of 1643. Arnauld, like many Jansenists, wrote brilliantly in French, preferring the common language to the usual theological Latin in order to appeal to a wide audience. He advocated abstention from communion until the contrition of the penitent sinner was manifest. Obviously, the meaning of the Sacraments was a subject of excited debate at the time. The influence of such movements as Jansenism, with its emphasis on the writings of the early Church Fathers, particularly Augustine, might also help explain Poussin's increasingly archaeological treatment of these themes: the second series of Sacraments is far more 'Early Christian' than the first. But we do not need to move out of the Roman milieu to account for most of Poussin's archaeology, which was a characteristic Counter-

Reformatory phenomenon that produced Catholic books such as Cesare Baronius's 'documented' *Annales Ecclesiastici* (1588-1607) and Antonio Bosio's *Roma sotterranea* of 1650, a monument of proto-archaeology in which the Christian catacombs were seriously discussed for the first time.[32] Poussin's blend of Christian and antique, found in such pictures as the *Sacraments*, is thus typical of the Early Christian revival of the Counter Reformation and was nourished by the increasing popularity of the writings of the early Fathers. Blunt has emphasized the fact that, like many of his contemporaries, Poussin was fascinated by what we would now call comparative religion. Many of Poussin's curious subjects and archaic treatments of these themes are best explained in this way.

Apart from the evidence of his pictures, we know only that Poussin was wholly sceptical of the bizarre and miraculous elements of the Roman Church. His biographers have almost no personal information to give us and do not emphasize his piety. Here at least we can contrast him with Bernini, who was constantly counseled by Jesuits and Oratorians and who, according to his official biography, worshipped at the church of the Gesù every evening. Poussin's only preserved comment on the Holy Year celebrations of 1650 was written to Chantelou: 'There is nothing more remarkable to report from here than the miracles that happen so often that it is becoming a source of astonishment. The Florentine procession has added . . . a wooden crucifix which is growing a beard, and its hair is becoming longer every day by four fingers. It is said that one of these days the Pope will give it a ceremonial shearing.'[33] Perhaps, after all, Poussin was not unlike a famous shoemaker of the time who 'became in turn a Lutheran, a monk, a pietist, and a Catholic once more, only to end his life as a Jew, because for him the only certain fact was the existence of one God.'[34] A combination of the rational and the religious, difficult for us to comprehend, was actually common in the Renaissance. We think immediately of Montaigne, one of the few writers ever cited by name in Poussin's letters, who, despite his scepticism, stoicism, and reliance on reason, was a devout Catholic.

The fashionable neo-Stoicism of the Renaissance, typified by Montaigne, Justus Lipsius, and others, was reconciled to a form of Christianity that was particularly Augustinian. These writers love to quote the great Church Father, who was described by Lipsius as *nostrorum scriptorum apex*.[35] Neo-Stoicism also infected Descartes, and we must remember that although he doubted everything, Descartes could not even conceive of a universe without divinity. So too, we might think of Poussin, who rarely quoted the Bible in his letters and never made reference to his personal religious beliefs. Despite the acid anti-clericalism of some of his statements, hardly surprising in the midst of a venal papal court, he seems to have kept an island of devotion and reverence at the core of his rationalism. But it is a very different piety from that of the Baroque theatricality of Roman church art of the time, epitomized by Bernini, with which Poussin must have been profoundly out of sympathy.

In addition to what seems to be a real, if non-sectarian devotion in the religious pictures, it may not be going too far to discover a kind of pantheism in some of the landscapes that become so important among Poussin's works of the 1640s and 1650s. This, too, was a contemporary phenomenon. One of the great Protestant mystics, the Bohemian Jakob Boehme (1575–1624), infused all nature with Christianity; such ideas were widespread, cropping up especially in England. A kind of pantheism is probably implicit in the thought of Descartes and later became explicit in the Augustinian philosophy of Malebranche. Very likely Poussin, with his sceptical turn of mind and his wide circle of acquaintances, which included its share of rather liberal thinkers, knew about most of these religious ideas and controversies, sifted them, and distilled what he cared to use. His religion was thus eminently rational. More than that we cannot say.

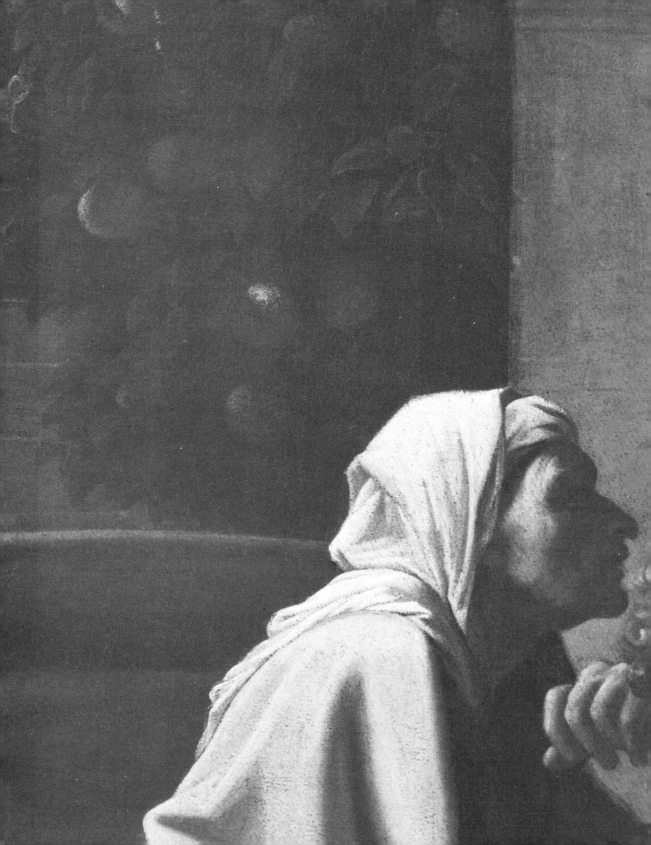

3. The Holy Family on the Steps

The Holy Family on the Steps, like many pictures by Poussin, was commissioned or at least purchased by a man of whom we know rather little, Nicolas Hennequin, Baron d'Ecqueville, Sieur de Fresne, who was 'Capitaine général de la vénerie des toiles' (Master of the Royal Hunt).[36] Hennequin seems to have had a taste for Giulio Romano, Raphael's saturnine pupil, and perhaps for Michelangelo – and these predilections could even explain the references to these masters in the picture. This must remain pure speculation, however, since we really know very little about Hennequin and even less about the circumstances of the acquisition of the picture. We do not know even that it was a commission, still less if the patron communicated his preferences to the great painter. This obscure patron, like so many others, seems in fact to confound those who would like to see a close correlation between patron and style in Poussin's works. Many critics have concluded, I believe correctly, that Poussin was his own man and that the patron got pictures in whatever style Poussin chose to paint.[37]

POUSSIN'S SOURCES

Friedlaender recently suggested that for part of the composition of *The Holy Family on the Steps* Poussin relied on the central section of the ancient *Aldobrandini Wedding* fresco, which he had reputedly copied [20]. 'Even the division between closed and open spaces, and between solids and voids, is generally similar in both paintings,' Friedlaender wrote, and went on to add that 'the problem of how to preserve an impression of depth without disturbing the unity of the surface is here admirably solved on the basis of the ancient example'.[38] This kind of connection with an actual work of antique

19. The Holy Family on the Steps, true-scale detail

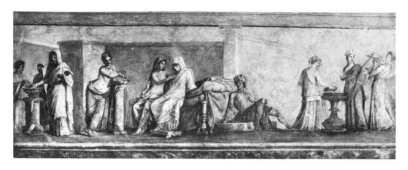

20. *The Aldobrandini Wedding.*
Roman fresco

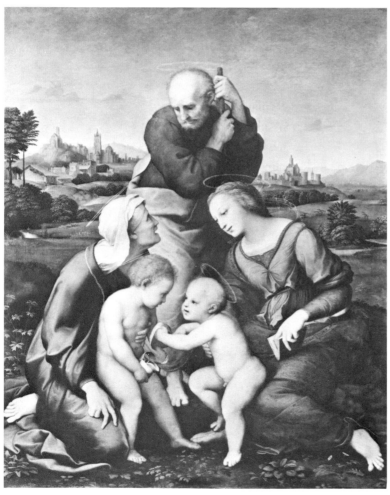

21. *The Canigiani Holy Family,*
1507. Raphael

art would make sense in view of our knowledge of Poussin's passion for the past. Nevertheless, in composition and in detail, *The Holy Family on the Steps* is also Poussin's clearest act of homage to the painters of the High Renaissance. Indeed, the glyptic, pyramidal rigidity of the central group at first seems almost a caricature of the formal ideals of that 'classic' period. When we compare Poussin's composition with its great prototypes – Leonardo's *Madonna and Child with St Anne*, Michelangelo's *Doni Tondo*, and Raphael's *Canigiani Holy Family* [21], we find that Poussin chose a lower point of view, a more broad-based triangle for his group. It is as if he were revising the compositions of the early High Renaissance in the light of the more expansive, multi-figural works of its maturity in the Stanza della Segnatura. But by concentrating on precedents of the Florentine-Roman school we are committing a Vasarian error and forgetting Poussin's earlier infatuation with Venice (see p. 28). The closest analogies to this triangular composition seem to be found in the works of Palma and Titian, although they are, predictably, far looser in their groupings than those of the Florentines [22]. Poussin is the most geometric of all.

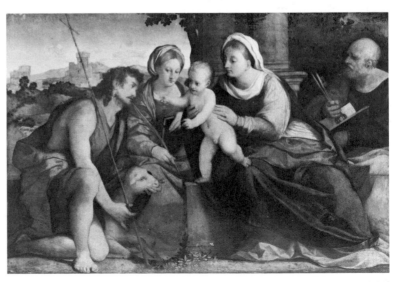

22. *Holy Family with Saints*, c. 1520. Palma Vecchio

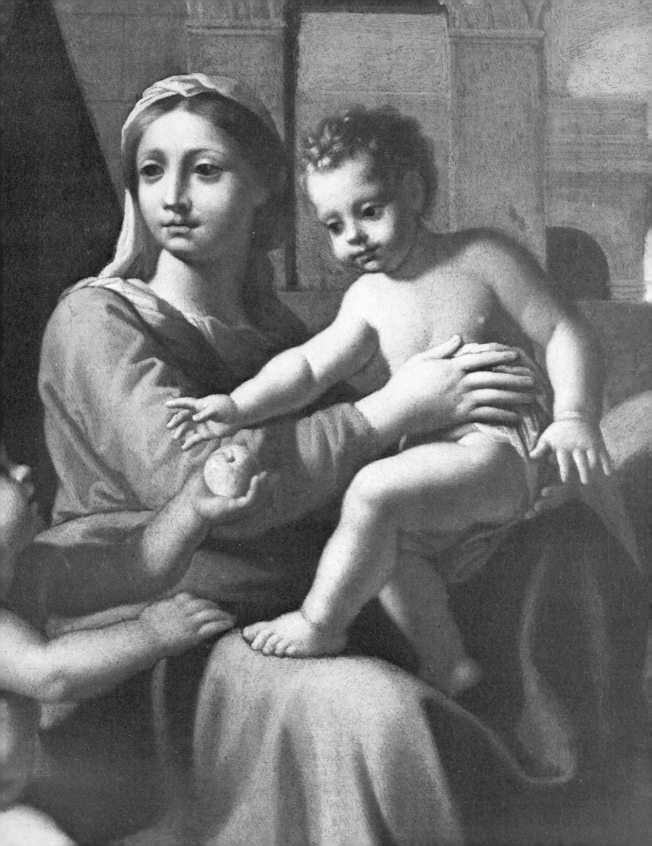

23 *(opposite)*. *The Holy Family on the Steps*, detail

24. *The 'Madonna of the Fish'*, detail, *c.* 1513. Raphael

In its general composition, *The Holy Family on the Steps* is a revised, monumental, even petrified act of homage to the Cinquecento and in a number of details scholars have found explicit reference to the great masters. The turn of the Madonna's head for example and her relationship to the upper body of the Christ Child [23] is closely based on a composition by Raphael, the so-called *Madonna of the Fish* [24], which Poussin would surely have known in a print by Marco da Ravenna, and possibly could have seen in the Neapolitan church of San Domenico before its removal around 1638.[39] The left side of the triangle is occupied by an elderly female figure,

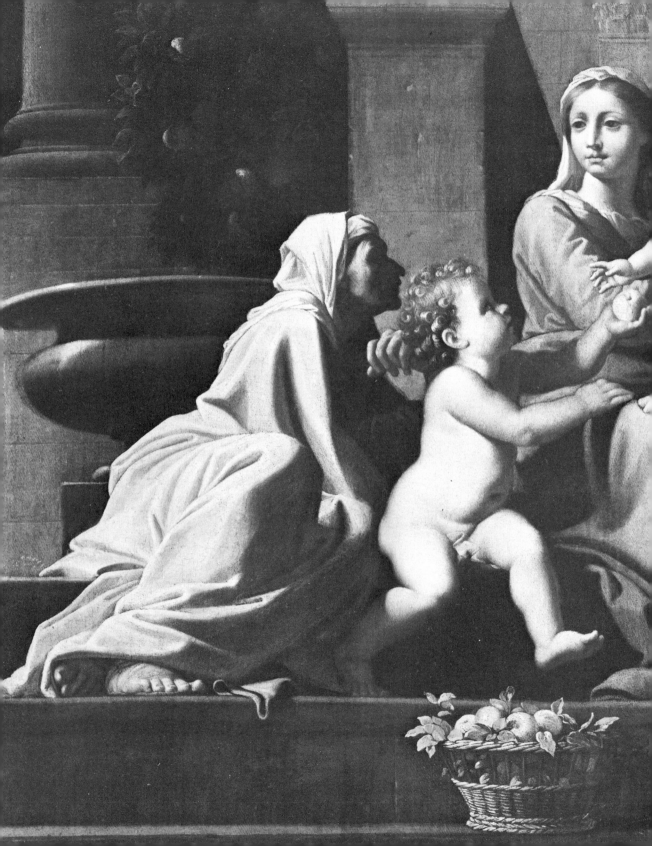

25 (*opposite*). *The Holy Family on the Steps*, detail

26 (*below*). *Putto*, 1633–40. François Duquesnoy

27 (*below right*). *The Persian Sibyl*, 1511–12. Michelangelo

evidently St Elizabeth since the nude boy is her son, St John the Baptist [25]. Elizabeth's haggard profile, cast in deep shadow, reminds us of the Sibyls and Ancestors of the Sistine ceiling, specifically the *Persica* [27]. The future Baptist appears to have plucked an apple from the wicker basket at his feet and, while seating himself on the step, offers it to the Christ Child. In contrast to the stony profiles of Elizabeth and Joseph and the Virgin's stately

head, both divine children are seen in arrested action. It is typical of Poussin's eclecticism that, although the Madonna and Child are obviously modeled on Raphael, the Baptist may be a partial reminiscence of an angelic *putto* carved by Poussin's companion of the early Roman years, François Duquesnoy [26]. Duquesnoy, who died in 1643, was a specialist in *putti*, drawing inspiration now from

28 *(opposite). The Holy Family
on the Steps,* detail

29. *The Madonna del Sacco,* detail,
1525. Andrea del Sarto

30 *(above right). Naason,*
1511-12. Michelangelo

Titian, now from Rubens. Poussin has translated the modeling of
the sculpture back into a High Renaissance linearism and definition.
This is of course consistent with his general tendencies in these
years (see p. 33). Much Baroque sculpture tends toward painterly
values; in the 1640s, Poussin increasingly favored the sculptured
forms of the past. The seated Joseph, shown in herm-like, almost
Giottesque profile [28], is related to the Joseph in Andrea del Sarto's
Madonna del Sacco [29]. The outstretched leg and foot must be a
quotation from a different source, however, one of Michelangelo's
Ancestors of Christ in the Sistine lunettes, the petulant Naason [30].[40]

The picture's coloration reflects the action, lighting, and general
meaning of the subject. This is what we should expect of the
mature Poussin, who carefully tuned his colors to the form and
sense of the composition. The general impression of the canvas is
dark, the prevailing tone the grey-brown stone of the architecture.
Set against this is the triangle of figures: Elizabeth in yellow-gold

stands out as opposed to Joseph, whose purple cloak is so deep that
the color is visible clearly only on his illuminated shoulder. Between
them is the Virgin in blue and red, prominent in the light. Poussin
used an almost Caravaggesque technique, perhaps dependent on a
follower like Gentileschi [34], picking out important figures and
parts with color and light. This gives an occult unity by means of
accents, such as Joseph's illuminated foot, which somehow balances
that recessive side of the picture with the more active and brightly
colored left half. The sense of atmosphere is strong and unifies the
whole. So dense and palpable is this invisible medium that the more

31. *The Holy Family
on the Steps*, detail

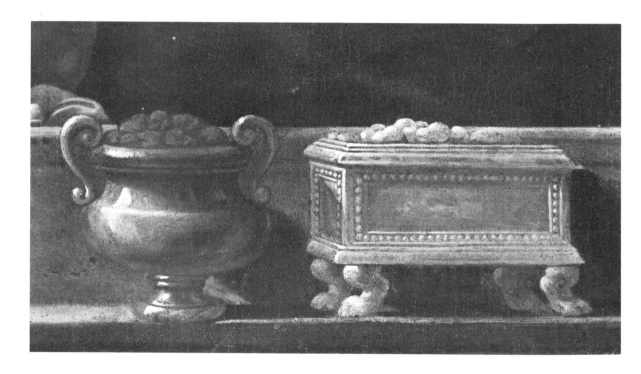

distant architectural elements are blurred, whereas the immediate
foreground objects, particularly the basket of red-streaked apples,
are very clearly and precisely painted [42].[41]

The still life on the bottom step of the painting is unique and,
because the vanishing point of the entire composition is just left of

the Virgin's foot, uniquely prominent. We see, set apart from the apples, a bronze vase and golden coffer below Joseph [31]. These objects are based on studies after the antique that Poussin had copied [32]. Blunt suggested that although the objects in the metal vessels 'are difficult to identify with certainty, they both appear to be some gum deposit, and may well be frankincense and myrrh'.[42] Thus the gold of the coffer, and the contents of both vessels, would recall a previous visitation by the Magi. Support for this attractive hypothesis is found in Poussin's painting of that subject, dated 1633, in which two similar vases appear as containers for the gifts [33]. These

32. *Antique Studies*, 1630–40. Poussin

33 *(below right)*. *The Adoration of the Magi*, detail, 1633. Poussin

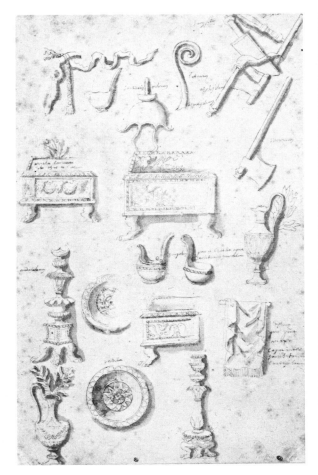

rare but inert donations, below the shadowy Joseph, contrast with the valueless but sunny and living and symbolically charged apples, which were evidently a gift from John and his mother [25]. The differentiation of the gifts coincides with a contrast of light, which divides the left, illuminated, and lively half of the figural group in the picture from the right, shadowed, and – as it were – dead half. In partial conflict with this interpretation, to which I will return because I believe it to be basic to the picture, is the emphasis scholars have laid on the enigmatic Joseph.

THE SUBJECT

'The Holy Family' is a pietistic invention with almost no biblical foundation. As a theme of religious devotion it seems to have been essentially a Renaissance conception. Its pictorial composition may have been a natural development from Annunciations and Nativities that tended to show Mary, often together with Joseph, in domestic circumstances. Some Holy Family compositions with added figures such as ours could have developed from the *Sacra Conversazione*, an invention of the Quattrocento that showed Mary and Christ, often enthroned, with various saints ranged on either side as if paying a visit – always a chronologically impossible one [22].[43] (Among other variations commonly interwoven with the theme of the Holy Family are references to Mary's unusual relationship to her mother, the apocryphal Anne, since in popular theology Mary was considered to have been immaculately conceived [56].) Most of these images, born of a demotic Christianity wed to memories of the families of pagan gods, have in common the relatively passive, often wholly subordinate role given to Joseph, which is of course in keeping with the supposed virgin birth of Christ [21]. More often than not Joseph is simply absent, in which case the composition is called a 'Madonna and Child' [24]. When present, Joseph is sometimes made to appear gently ridiculous, as in Gentileschi's numerous ver-

34. *The Rest on the Flight into Egypt*, *c*. 1626. Orazio Gentileschi

sions of *The Rest on the Flight into Egypt*, where the exhausted old man has fallen sound asleep [34]. Nevertheless, the hagiographers of the Renaissance found time even for Joseph, whose day finally came in 1522 with the publication of Isidoro Isolano's *Summa de Donis S. Josephi.*[44] Isolano must be the source of Sarto's idea of a Joseph who reads [29] and of Poussin's Joseph who draws with compasses. Both imply that Joseph was more than a humble, illiterate carpenter. He has become, in fact, something of a learned man, for a book, in iconographic shorthand, equals wisdom, often theological wisdom. In an earlier painting of *The Holy Family in the Temple* Poussin showed Joseph leaning on a measuring rod, with a carpenter's square hanging nearby [35]. The implication may be that Poussin thought of Joseph not merely as learned but as a master of mathematical or architectural science. Propped against the wall of the steps at the right of our picture is the shaft of another T-square. By contrast, two of the preserved drawings that seem preparatory or at least closely related to our composition show Joseph reading [46, 48]. As he evolved the composition Poussin may first have been attracted by the idea of a theologically learned Joseph;

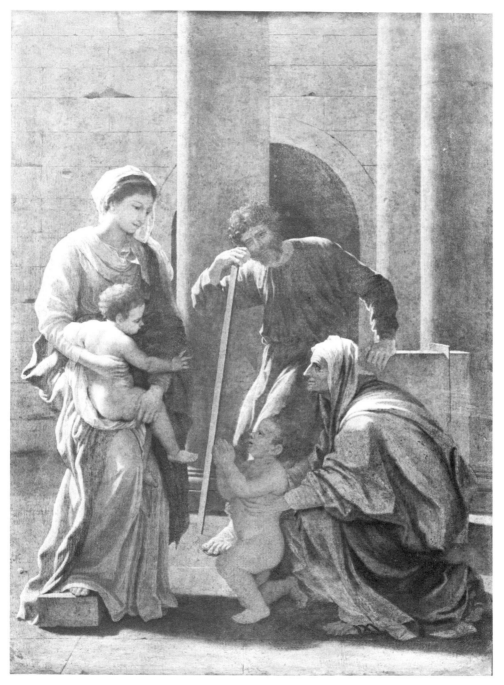

35. *The Holy Family in the Temple,* *c.* 1640-43. Poussin

later he switched to mathematical or architectural learning, which he himself greatly admired. In a famous composition by Barocci we see much the same subject: a visit by Elizabeth, John the Baptist, and Zacharias to the Holy Family [36]. Joseph welcomes the visitors, having put down his tools of carpentry, which include dividers. Poussin's image could, after all, simply refer to the more genteel aspects of Joseph's traditional profession. But Poussin was rarely content with the merely simple, and the picture shows, as do others

36 (below). Copy after Barocci's *Holy Family Visited by the Family of John the Baptist, c.* 1588-93

37 (below right). *Flight into Egypt,* 1630s. Guido Reni

of the age, an interest in Joseph as a saintly figure in his own right, a full-fledged member of the Holy Family. This relatively new devotion to Joseph was expressed by Guido Reni in the later 1630s in a painting that, although actually a *Flight into Egypt,* isolates Joseph carrying the Christ Child, an analogy to the traditional image of the Madonna [37].

The unusually rigid figural composition of our Holy Family almost seems to be part of the stony architecture that is so prominent. The triangle of figures appears to rise naturally from the steps, which lead to what can be called a petrified landscape. The meaning of these elements will concern us later; a source for Poussin's conjunction of foreground figures with a background of classical architecture is found in paintings by one of his older contemporaries, Domenichino. Poussin had studied Domenichino's works and defended them against general neglect and criticism; in Poussin's

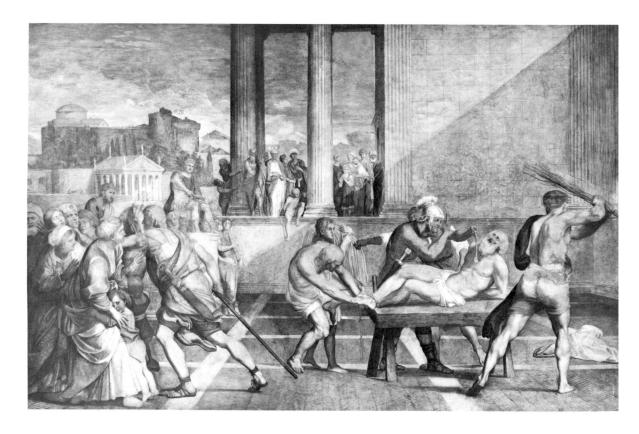

first Roman years it would seem that he alone had adequately appreciated Domenichino's *Flagellation of St Andrew* [38]. The cutoff temple porch seen from below, central in *The Holy Family on the*

Steps, is almost equally prominent in Domenichino's famous *St Cecilia Distributing Clothes to the Poor* [39]. Poussin was something of a student of architecture and he was a believer in the Vitruvian theory that the antique orders were based on human proportions. In 1642 he wrote to Chantelou, who had recently visited the Roman monuments of Nîmes: 'The beautiful girls that you will have seen in Nîmes did not, I am sure, please you any less than the beautiful columns of the Maison Carrée, since the latter are only old copies of the former.'

38 *(opposite). The Flagellation of St Andrew*, 1608. Domenichino

39. *St Cecilia Distributing Clothes to the Poor, c.* 1617. Domenichino

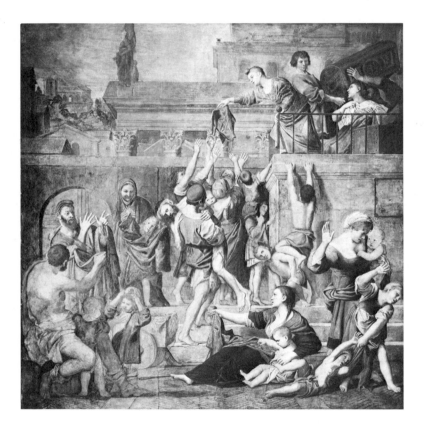

The architecture of our painting is scenographic rather than structurally believable, and the unusually low viewpoint cuts off the columnar temple at the left, showing only that it has a porch two

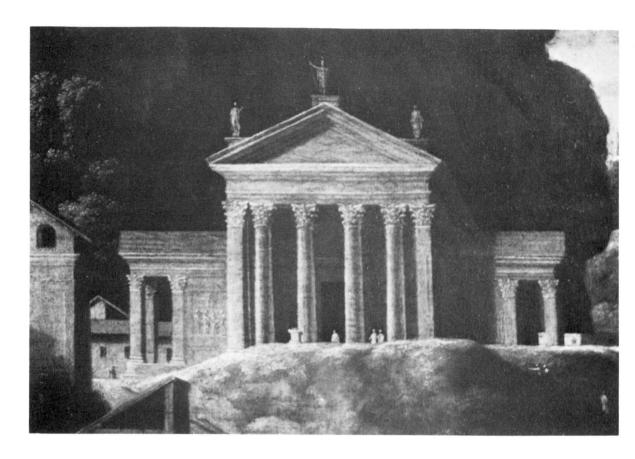

columns deep. The evidently shallow portico behind Mary and
Jesus is very close in form to the side projections of the ancient
temple near Trevi, illustrated by Palladio; Poussin used that temple
in the year he finished our painting as the distant focus of the grave
landscape, *The Ashes of Phocion* [40].[45] Given this fact, we may
even suppose that the two apparently separate buildings at the left
and center are versions of this same structure although the left-
hand temple does not obviously or necessarily join the wall behind.
It has been suggested that the classical buildings in our picture,
whatever their formal source, represent the Temple of Jerusalem
and that the Holy Family is sitting on the steps of the Temple pre-
cinct. This appealing idea may get some support from the archi-

tecture in Poussin's representation of St Peter and St John healing on the steps of the Temple, painted in 1655 [41].[46] *The Holy Family on the Steps* is one of the most architectonic of Poussin's pictures; if Joseph stands for architectural learning and if the buildings do represent the Temple, the figure of Joseph would emerge as an un-

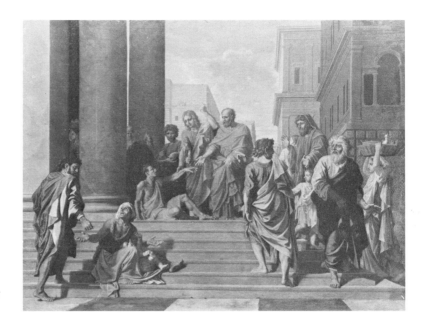

40 *(opposite). The Ashes of Phocion*, detail, 1648. Poussin

41. *Peter and John Healing on the Steps of the Temple*, 1655. Poussin

expectedly potent symbol. The Temple of Jerusalem was built according to measurements given to Solomon by God (I Kings, 5–6). This connection might also explain the measuring rod and T-square in the earlier *Holy Family in the Temple* [35].[47] Joseph becomes endowed, according to this line of reasoning, with God-like wisdom; he sits before Solomon's temple as a representative and symbol of inspired measure and proportion. Certainly the whole picture is permeated with the sense of a divine proportion or golden mean. Still, the Temple represents the wisdom and harmony of the Old Testament, not the New, and that would explain why Joseph is cast in shadow and faced away from the Madonna and Child. He sits before a temple precinct that is partially cut off from sight and sub-

ordinated to the group on the steps and to the glorious sky. Like an Old Testament book-end, he supports the central, New Testament group.

Opposed to the inanimate objects on the step, the dry architectural symbolism, and Joseph's shadowed, static profile, is the left side of the picture – the part to Christ's right – full of life and light [25].[48] There we find Elizabeth and John making an extra-biblical visit. The only meeting recorded between Mary and Elizabeth in the Bible, the so-called Visitation, took place before their divine children were born (Luke I, xxxix ff.). (The Gospel of Luke opens with an account of the miraculous conception, not of Christ, but of John; the parallel miracle of Christ's incarnation then follows.) Elizabeth's importance is given its only biblical authority here, not only as the mother of the Baptist but also as a prophetess. According to Luke, Mary came to visit 'and greeted Elizabeth. And Elizabeth was filled with the Holy Spirit and cried aloud, "God's blessing is on you above all women, and his blessing is on the fruit of your womb. Who am I that the mother of my Lord should visit me? I tell you, when your greeting sounded in my ears, the baby in my womb leapt for joy. How happy is she who has had faith that the Lord's promise would be fulfilled."' (Luke I, xl–xlv). I am sure that Poussin fully understood this prophetic aspect of Elizabeth; here, as we have seen, and also in other Holy Families, he gives her a specifically sibylline aspect [35, 43, 56].

The textual tradition for a visit of Elizabeth and John to the Holy Family, although not biblical, is very old, beginning no later than the fourth century. This kind of romancing embellishment of biblical stories had great appeal to the men of the Middle Ages; and since Mary and Elizabeth were related, such a visit was not wholly unlikely. One author, expanding on the theme of the infancy of Christ, wrote that the Holy Family escaped to Nazareth to avoid the massacre decreed by Herod. There they met the family of John, his

mother and also his father Zacharias. The version more familiar in the Renaissance relates that John was taken to Bethlehem by his parents to see the new-born Saviour [36].[49] If we are to assume Poussin's familiarity with the actual texts of these legends, the site of our picture would have to be Bethlehem or Nazareth. The theme of the visit became so common in Italian Renaissance art, however, that we are safe in assuming that Poussin probably had no such knowledge: there are countless earlier paintings of the subject [21]. Assuming that Poussin's interest or knowledge of the early origins of the story was weak, we can simply follow the lead of the painting in trying to puzzle out which place Poussin was suggesting. As we have seen, the site is most probably Jerusalem.

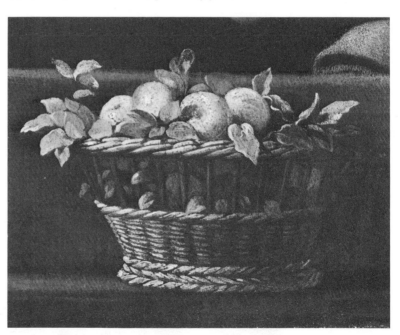

42. *The Holy Family on the Steps*, detail

In this lively left side of the picture are not only the apples but also an orange tree full of ripe fruit, a vase of lush greenery, and a splashing fountain [25]. The fountain's symbolism is commonplace, especially in the presence of John the Baptist. The infant John in

art was often no more or less than a symbol for baptism; Poussin expressed this meaning even more clearly in a gracious *Holy Family* painted shortly after ours [43].[50] The water and John the Baptist on the left side of our painting immediately call forth thoughts of baptism and salvation. Perhaps Poussin's constant concern with purification and rejuvenation in his religious paintings of this period reflects a keen but guarded sentiment that the Church again needed spiritual cleansing.[51]

The apples also have rich connotations. The Bible is full of fruits; and although the word used in the Hebrew text is now sometimes

43. *The Holy Family with the Tub,*
c. 1650. Poussin

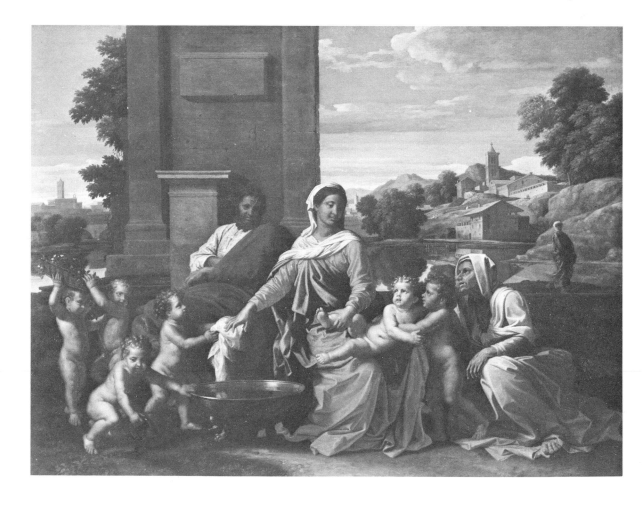

translated as 'apricot', the Latin of St Jerome's standard translation reads *malus* (apple), as for example in the Song of Songs (2, iii):

Sicut malus inter ligna silvarum,
sic dilectus meus inter filios.

(As the apple tree among the trees of the wood,
So is my beloved among the sons.)[52]

44. *The Holy Family with the Tub,* detail

We should recall that St Augustine first laid down the rule that things in the Bible that do not obviously relate to theology or morality should be interpreted allegorically.[53] Until the eighteenth century, the Song of Songs was usually so interpreted. Far-fetched though it may seem now, the Beloved mentioned in the passage above was taken to be Christ, and his mistress-bride as the Church or Mary. Hence the apple held by John in our picture may be reminiscent of this popular belief.

More obviously, the apple in John's hand recalls the fruit of Genesis and man's first fall from God's grace. In Catholic thought Mary was universally believed to be a new Eve who redeemed the sin of her predecessor. The seemingly accidental positioning of the succulent apple directly in front of Mary in Poussin's painting gives us a clear reminder of that familiar doctrine [23].[54]

In some slightly later paintings of the subject Poussin produced relatively relaxed, genre-like scenes such as *The Holy Family with the Tub* [43]. The charming stylistic *détente* that we find there, striking after the rigors of our picture of 1648, is typical of only one aspect of Poussin's art of the 1650s [cf. 18]. But we should not mistake the fact that many of the symbolic elements of our *Holy Family* re-appear: the young John tries to support Christ; and the water is, as we have seen, even more obviously baptismal. Elizabeth and Joseph are again in subordinate positions. There may even be a similar contrast of the part on Christ's right to that on his left: a basket of fresh flowers is carried in at our left; a mysterious covered figure, perhaps representing *Synagoga*, leaves at the far right [44].

THE DRAWINGS

Before going further, we had best examine the preparatory draw-
ings for *The Holy Family on the Steps*. An unusually large number
survive, although it is not always possible to separate studies for
our picture from others, since Poussin worked on his compositions
over a long period of time and an idea discarded for one picture was
often a generating force for another. Thus after our *Holy Family*,
which Félibien says was finished in 1648,[55] Poussin produced four
more, two of which are reproduced here [43, 56; cf. 49], that can be
dated 1649–52. All this in addition to *Adorations of the Shepherds*
and still more *Holy Families* of the mid- or later 1650s [18], makes
the isolation of specific drawings a difficult enterprise.

One study apparently for *The Holy Family on the Steps* may date
as far back as 1645–6 because it is on the back of a drawing pre-
paratory for a *St John Baptising* that was painted in 1646 and doubt-
less conceived somewhat earlier [45].[56] This drawing, in Dijon,
already shows the general composition and lighting of our picture;
the viewpoint is low, but only the Madonna, Child, and Joseph are

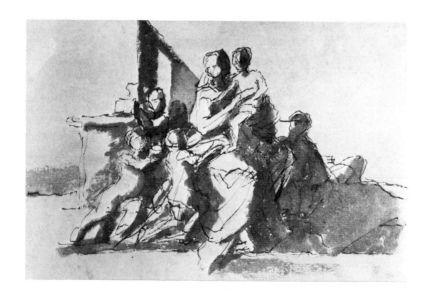

45 and 46. Preparatory drawings
for *The Holy Family on the Steps*,
c. 1646. Poussin

specified; the places of Elizabeth and John are taken by *putti*. There
are as yet no stairs, but the group is seated on two levels, one of
which is defined at the right edge as a step. A construction to the
left, possibly the manger, seems to foreshadow the juxtaposition of
Mary with the wall and urn that make so prominent a parallel in
the finished painting. The left-hand *putto* is in the half-sitting pose
of the final John the Baptist [25]. Here, obviously, we have a 'pure'
Holy Family; the idea of a visit from John and Elizabeth has not yet
occurred.

What appears to be the next chronological step in the preserved
series of drawings is one [46] at the Morgan Library in New

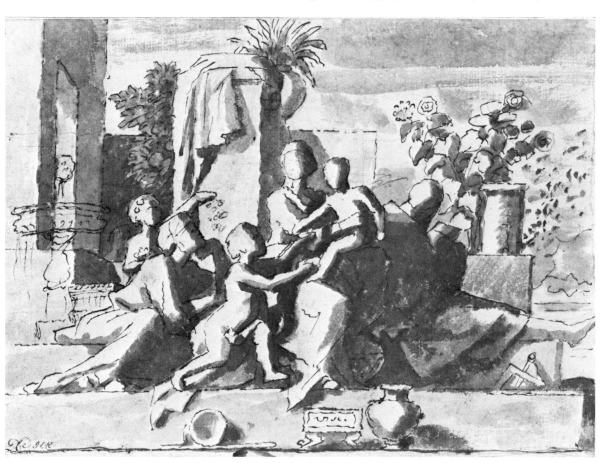

York.[57] The figural composition of the painting is now essentially set, with the addition of a half figure behind Elizabeth that was later dropped. Joseph reads a book but has dividers and a square below him. The Baptist is identified by a bowl and staff, which form part of a still life that now appears on the bottom step of a kind of dais.[58] The other two elements of the painted still life appear reversed below Joseph. The fountain is sketched in; a palm tree and other foliage seem to indicate a desert setting. The vague architecture to the rear is not that of the final picture, but two levels are nevertheless now clearly defined in the foreground. Joseph's leg is extended as in the final work. A sketch for this pose was recently discovered by Georg Kauffmann; it has been dated *c.* 1645 and, more recently, *c.* 1647 [47].[59]

47 and 48. Preparatory drawings for *The Holy Family on the Steps*, *c.* 1647. Poussin

A third and larger composition drawing, in the Louvre, shows the same group on steps, with alternative solutions for the background, including an arcade to the left [48].[60] In general, the figures are placed considerably higher than those of the painting, but the

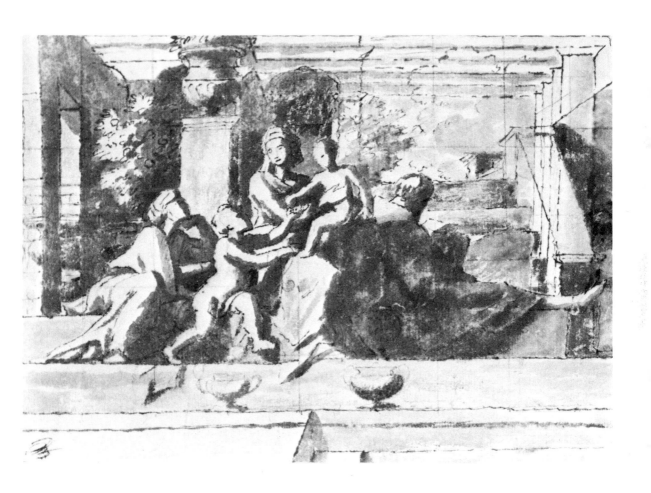

low viewpoint of the Morgan drawing is maintained. This is presumably the most advanced drawing, seen with respect to the painting, but further stages in the creative process must be imagined between the drawing in the Louvre and the final work. Other drawings, closely related in some respects, branch off in other directions. One [49], which seems also to have developed out of the Dijon

49. Preparatory drawing for
*The Holy Family under a Group
of Trees*, *c.* 1650. Poussin

state [45], is obviously related to a painting of *c.* 1651 now in the Louvre. Another drawing [50], perhaps of about the same time, seems equally related to our *Holy Family* and to the last mentioned drawing.[61] Thus the chronology of the drawings and of the paintings is not necessarily parallel. Poussin was experimenting with

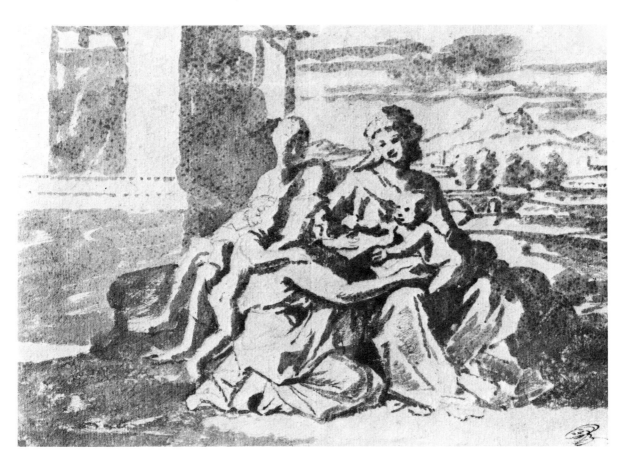

50. Preparatory drawing for
A Holy Family, c. 1648. Poussin

compositions for Holy Families in the middle and later 1640s, but his execution of a painting of the subject had to await completion of the *Sacraments* for Chantelou, who increasingly pressed his friend for the remaining canvases. In a letter of 24 November 1647, Poussin had to reassure him that he would use his brushes only in Chantelou's service until the completion of the series, which was in

fact finished the following March. Poussin's astounding production in 1648 – both in quantity and quality – proves that he had already begun, or at least carefully planned many of the pictures, for he was a slow, deliberate painter who felt happy if he could complete one good head in a day's work. Moreover, he often found it quite impossible to paint during the heat of the Roman summer. But he thought about his compositions and worked on them in his mind and on paper over long periods. For example, a *Holy Family* for Chantelou, first mentioned in 1647, was finished only in 1655 [18] (see note 63). Thus there is good reason to imagine that he had begun planning and even painting our *Holy Family* before 1648.

I want to insist that a clear, easy development from what appears to be the earliest preparatory drawing to the latest may well be illusory. Later on, in a letter of 1653, Poussin gives a little insight into his unmethodical planning procedure: after he had already been thinking about Chantelou's *Holy Family* for some time, 'another idea came to me', as he wrote to his friend, and that was the one he used. But we can just as easily imagine him rejecting the new idea and reviving an older one. Hence the difficulty of an absolute chronological sequence will always remain. The complexities are neatly illustrated by the most 'advanced' drawing in our series [48], which lacks the developed still life found in the evidently earlier Morgan drawing [46].

By reviewing the drawings as a potential sequence, however, and ignoring other thoughts that were part of Poussin's normal creative process, we can draw some conclusions about the development of his conception. First he seems to have been chiefly concerned with the pyramidal grouping, which starts in the Dijon drawing as a more or less equilateral High Renaissance composition [45]. We already see the contrast of sun and shade that is prominent in the painting. The fact that Poussin kept the contrasted lighting in the picture is significant, for his preparatory procedure was commonly to block out compositions in broad areas of light (paper) and shade (ink), which then evolved into more evenly lighted, classical look-

ing paintings.[62] In other words, his drawings are far more spontaneous, lively, and full of light and dark contrasts than are his paintings. In the Morgan drawing the pyramid of figures has been given more meaning by the addition of Elizabeth and John; perhaps their addition was at first merely for compositional reasons [46]. The still life, and its partial association with the figures above, is highly evolved but different from the painted one. In the Louvre drawing [48] the background is still in question – no drawing shows the architecture as it was painted – and the foreground is inchoate. But there are steps behind Joseph. Thus, from the unusually full evidence at our disposal, the addition of an architectural, rather than a landscape background seems to have been one of the last basic decisions Poussin made before fixing the composition in paint. In addition, he revived and modified the still life of the Morgan drawing [46] in accordance with the new and richer meaning that the apples infused into the composition, completing the idea of two sets of gifts. These foreground and background changes were then combined with the scenographic stairway of the Louvre drawing.

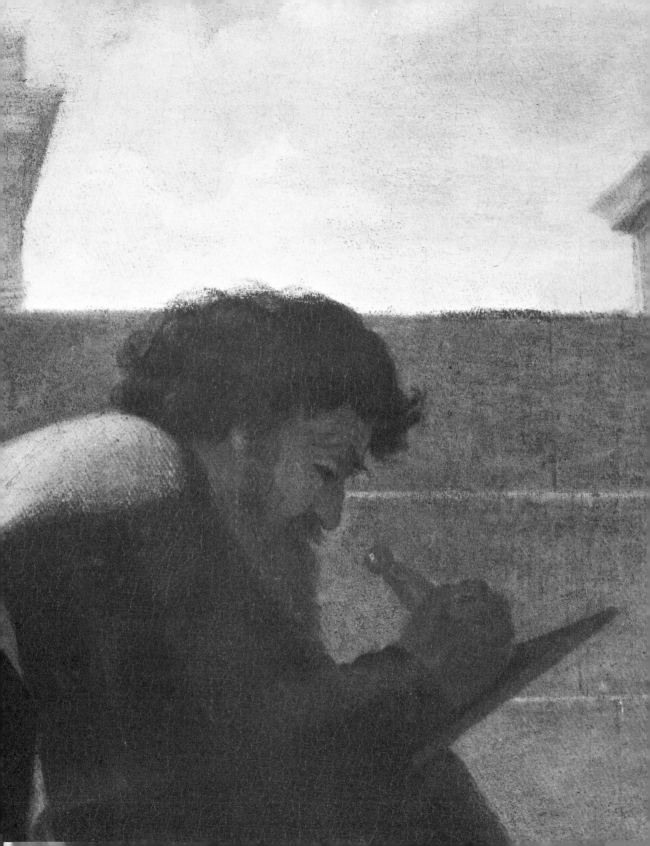

4. Scala Coelestis

Poussin's conception evolved gradually, as the drawings show, and such a sequence of drawings is usually discussed as a mere formal groping for a final stylistic solution. But since every element of the picture is highly charged with potential symbolic content, every change and choice takes on significance. A drawing of Mary enthroned [17], which has been dated 1649, may in fact go back to ideas in the *Marriage* [16] of 1647–8 (the swags alone would seem to connect them).[63] Our Madonna, too, sits on the steps as if formally enthroned, her stately head and neck echoed by the wall and urn to her right, her left foot posed elegantly on an amphora. (This richly allusive interplay between human and geometric congruity is found in another painting of the same year, *Rebecca and Eliezer* [52] in the Louvre.) Our Mary is no 'Madonna of Humility' or simple mother dandling her infant; she resembles an enthroned goddess-queen.

51 *(opposite)*. *The Holy Family on the Steps*, true-scale detail

52. *Rebecca and Eliezer*, 1648. Poussin

Her dream-like face, of asymmetrical perfection, seems to exist in another world; her antique eyes seem to see, not mundane things, but a glimpse of heaven [53].[64] Perhaps here, as elsewhere, Poussin recalled a theological concept of the Middle Ages according to which 'the Holy Spirit . . . found in Mary a throne, to receive and sustain the Wisdom that was to come in Christ. In representations of the thirteenth century and afterward Mary appears upon the elaborate structure of Solomon's throne, and, as she herself constitutes the seat of wisdom, she may even physically replace the chair or bench.'[65] This concept seems relevant to our image, as does another, related idea, for the stony steps on which Mary sits may also have a specific meaning. When Mary is seated or enthroned above a stone or rock (*super petram*) the image signifies that she is founded on Christ – 'like the Church itself, at the same time supporting Christ and being founded upon him'.[66]

The Madonna had been worshiped officially since the Council of Ephesus in 431 because of her role as *theotókos*: Mother of God. The central subject of our picture is clearly the young Godchild presented, as it were, to the world by his proud mother. The Magi have come and gone, as have the shepherds. Now Mary's elderly cousin Elizabeth and another holy son, John, have come to proclaim and worship the Christ. The first engraving made after *The Holy Family on the Steps*, by the niece of Poussin's old friend Jacques Stella, was given the subscription 'Vere tu es deus absconditus: Isa. ch. 45' (Truly you are the hidden God).[67] Although this title may be merely an addition *post facto*, it seems to accord with what we have discovered in the picture, which is an icon of the incarnation replete with references to the superseded world of the Old Testament. The painting can be considered emblematic of the new era of the world under Christian grace (*sub gratia*) framed by relatives and gifts and a background pertaining to the older world under Mosaic law (*sub lege*). And it may not be too fanciful to see that Old Testament law represented here by the stern realm of mathematical and architectural science, personified by Joseph, and exemplified by the

53. *The Holy Family on the Steps*, enlarged detail

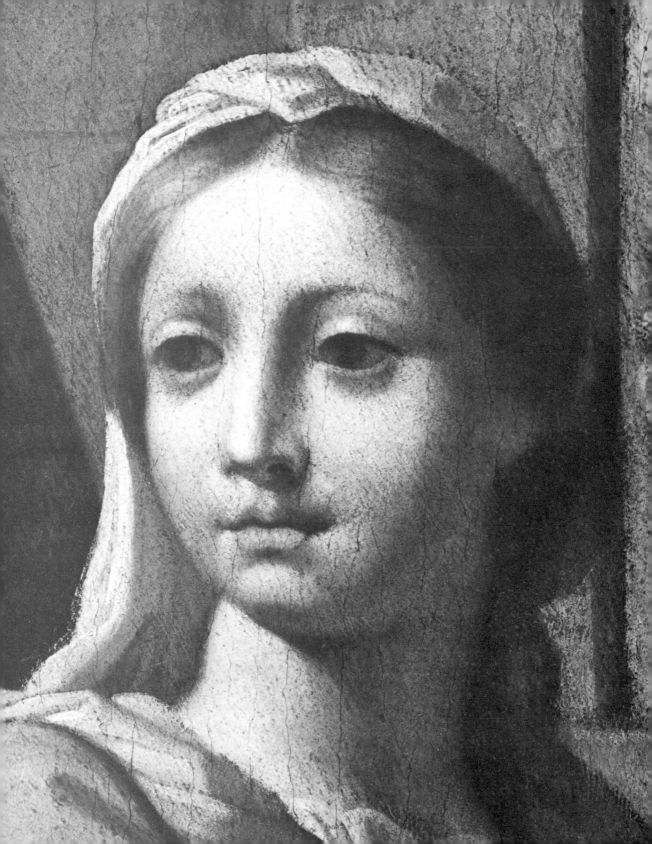

architecture in the background – which is probably the Temple. In popular thought from Early Christian times onward Mary was considered the equivalent of *Ecclesia*, or the Catholic Church. Mary enthroned before symbols of the ancient world, such as these Roman buildings, was an obvious conceit. In the foreground, then, Mary-Ecclesia, the new Eve, and Jesus, the living, previously hidden God, sit at the center of a radiating web: between their precursors and amid symbols of sanctity belonging to the superseded pagan and Hebrew worlds. The contrasts of living and dead, light and dark, left and right, mundane and heavenly, all come to a focus on the Madonna and her Child, who wears as a 'natural' halo a slice of blue sky shining through the Temple portico.[68]

The light in our picture seems rational in its illumination of the foreground figures although, as we have seen, it is carefully adjusted to the meditated composition in order to throw the pre-Christian personages into shade. John the Baptist, strongly illuminated, nevertheless turns into the shadow so as to gesture upward towards Mary and Jesus, who alone face the intense light. John, 'the last prophet and the first martyr', is clearly the vital link between Old and New. The imagined source of the illumination has little naturalistic connection with the brilliant sky and clouds, which resemble a sunrise or sunset. In Latin and Romance languages, 'sky' (*coelum, cielo, ciel*, etc.) is also the word for heaven. Even the clouds may symbolize God: Robert Bellarmine pointed out to the men of the seventeenth century that in the Hebrew language one word served both for 'cloud' and for 'heaven'.[69] Light, or the sun, is of course a timeless symbol of God. The light in our picture, then, like so many other elements in the composition, is partly formal and partly metaphoric. Jesus signifies the dawn of a new era that is exemplified by the illumination, just as its divine source is symbolized by the brilliant sky.

We have not yet discussed the steps. They are so prominent in the composition that they have always given the picture its name.

Architecturally the steps are irrational, supporting the figures and then continuing upward steeply behind Joseph. Surely they began as a simple compositional device [46, 48]. Their final prominence, like the temple landscape and the basket of apples, was apparently one of Poussin's last additions to the composition. Like other late additions, the steps probably have a meaning and purpose beyond their compositional function. In our discussion of possible meanings for these and other features we should remember that an artist himself is not always conscious – cannot even possibly be conscious – of all the various reasons that lead him to use or omit any given element in a painting. The great artist, more easily than the rest of us, draws upon unconscious, forgotten, or half-remembered wellsprings of memory and experience – what Ernst Kris called psychological regression in the service of the Ego.[70] Only such a theory can explain the complex but often complementary interpretations pertinent to, say, a few lines from a play by Shakespeare. This richness, which includes layers of meaning that are not revealed to any given viewer or reader, is the partial result of a psychological process that has been called, somewhat clumsily, 'overdetermination'.[71] In its original psychoanalytic context, this term means that a neurotic symptom is the strange result of continued, varied, and often long-forgotten or repressed stimuli ('causes'). Overdetermination, with its mixture of present and past, repressed and remembered, gives our dreams their confusing welter of suggestive meanings. So too, *mutatis mutandis*, works of art. Now, apart from the formal function of the steps in our painting – which should not be forgotten – there are a variety of associations that steps or stairs more or less inevitably carry with them.[72] One of the most familiar subjects in the life of the Virgin was her presentation at the Temple, an apocryphal scene like the rest, which usually shows the brave little girl isolated against a flight of stairs. Such memories and associations would almost inevitably have made any Renaissance artist couple Mary with steps, and Andrea del Sarto painted a pic-

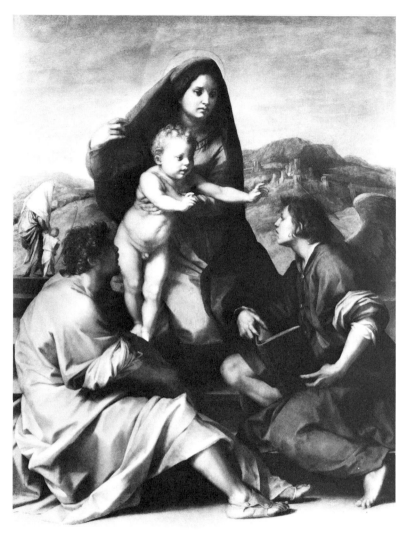

54. *The Madonna della Scala, c.* 1522. Andrea del Sarto

ture given precisely that title, the *Madonna della Scala* [54]. In Poussin's picture, as we have noted, Mary sits as if enthroned, as in Raphael's *Madonna of the Fish* to which, as we have seen, he was indebted; and thrones typically have steps before them. Moreover, for one reason or another, no less than three Roman churches were dedicated to Santa Maria della Scala: St Mary of the Steps (or ladder).[73] In addition, Michelangelo, at the inception of his career, had carved a relief of a *Madonna of the Stairs* [55] that was

55. *The Madonna of the Stairs, c.* 1491?
Michelangelo

visible in Poussin's day, as in ours, in the Casa Buonarroti in Florence, a building that had been remodeled into a kind of shrine to Michelangelo in the years preceding Poussin's arrival in Italy.[74] Poussin's composition is step-like: Elizabeth and Joseph sit on a low step, as does John who, however, reaches across Mary to Jesus, who is seated higher still on his mother's ample hand. We have seen that the lower part of the picture divides roughly into a darker right half and a lighter left. But the sky above Joseph is the brightest spot in the entire composition, and this can also lead us to divide the painting in a somewhat different way, into a gigantic X that goes downward, stepwise, from the upper left, past Joseph, and upward through the left and central figures, following the highlights, until we reach the brilliant sky. We have proof in a number of drawings and paintings that Poussin was thinking of X compositions at just this time, most obviously in another *Holy Family* of 1649 [56]. There too the Madonna is seated, as it were, *super petram* (see p. 82), and there too are steps. Since this is the *Madonna* closest in date to ours, these repetitions take on greater significance. The step-like descent of the architecture in our picture carries down to Joseph with his dry symbolic action. The upward progression from John to Christ, accentuated by the light, continues logically up to the burst of glorious sunlight on the clouds. The painting thus seems to impose upon us a clear route to heaven, via the Old Testament, through Mary, to Christ who leads us to the light of the true God.

56. *The Holy Family with St Anne, St Elizabeth and John the Baptist*, 1649. Poussin

The idea of a stairway to heaven is very old: Jacob dreamed of one, John Climacus wrote of one, and artists diligently illustrated their visions. But Poussin's painting is not such an image.[75] When we look again at the composition with all its focus on the Madonna and Child, set against a background of steps, and placed in the center of a cross-shaped intersection of descending shade and ascending light, we remember – or might, if we were men of the Renaissance – that a text ascribed to St Augustine described the Virgin Mary as

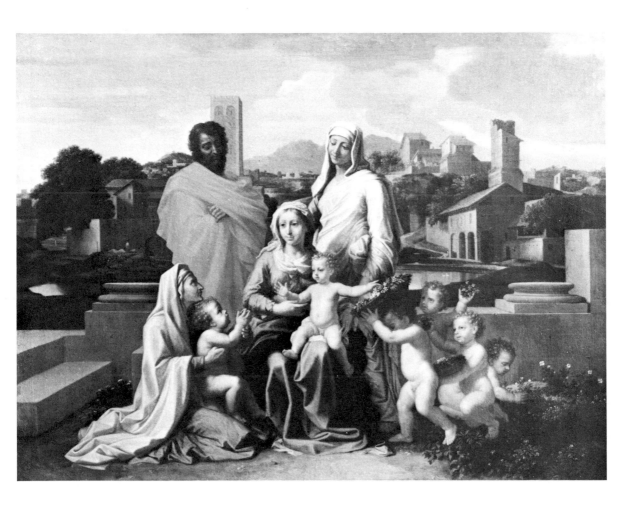

the *fenestra coeli* and as the *scala coelestis*: the window and stairway to heaven.[76] The synopsis of one section of the sermon entitled 'On the Birth of the Lord', reads: 'Mary window and stairway of heaven. Restorer of woman. Mary good vs. Eve bad.' Here we seem to have, in a nutshell, the meaning of our painting: the redemption of the sins of the Old Testament by the divinity of the New, personified by Mary as the new Eve who is the stairway to heaven. 'Augustine' wrote: 'In fact Mary is the window of heaven, through which God shines light on posterity. In fact Mary is the heavenly ladder by which God descends to earth, so that through her,

men who merit it ascend to heaven . . . ' This idea was repeated in
the Middle Ages by Fulgentius and countless others,[77] was picked
up in the Renaissance by Savonarola, and must have remained a
current rhetorical image in Poussin's time. A poem written in
memory of Savonarola invokes the

> *Holy Virgin, immaculate and pure*
> *Stairway to heaven and Empress . . .*[78]

Such ideas must have continued to be current and even popular in
the Counter-Reformatory period even if this particular poem was
forgotten. In other words, the idea of Mary as the *scala coelestis*,
which has taken us so long to discover, was probably a common-
place in Poussin's day.[79] Our picture thus becomes a geometrical
paradigm of purification and salvation through the agency of
Christ. Mary was the stairway by which God descended to the world
in the form of Jesus. But she is also the stair by which we can ascend
to heaven. Poussin actually shows a stairway behind Mary, sharply
foreshortened, leading directly up to the brilliant sky.

In one of his best-known letters, to his friend Jacques Stella,
Poussin wrote at length of his painting *The Israelites Gathering the
Manna*; he concluded by saying that what he had described were
'things which, I believe, will not displease those who know how to
read them' (*ceux qui les sauront bien lire*). In another letter Poussin
advised Chantelou to 'read the story and the picture . . . ' Poussin
produced pictures that he himself wanted to be read rather than
simply seen. Our analysis has tried to provide such a reading.
Nevertheless, it is a tentative one, with alternatives and many un-
certainties, for *The Holy Family on the Steps* is, in spite of its super-
ficial clarity, not a text but a work of art. These figures, so strange
and even awkward in their preternaturally eternal poses, seem to
hint at a glimpse of perfection and order that even Poussin could
not quite attain. Perhaps this perfection, which includes symbols
of proportion and measure together with the symbolic, divine per-

fection of Mary and Jesus, reveals Poussin's motive. St Augustine thought that Beauty was best realized in what he called 'number' (*numerus*), which can be interpreted as 'a sense of rightness in the order of things made, a sense which grows and deepens through prolonged contemplation of God's work'.[80] Augustine thought that the artist 'creates a transparent sensory thing through which the order of beauty, an imitation of divine beauty, is discovered'. This picture, more than any other I can think of, seems to illustrate this Augustinian theory. The picture exudes a sense of the hermetic, the strange and unknowable. Like a vision frozen in some pellucid medium, it remains to haunt us, hinting now at this, now at that. Despite all our conjectures and half certainties, we are forever unsure of finding a true, or single meaning. But this is merely an outstanding example of the power of all great works of art, which remain ultimately mysterious despite the efforts of scholars, writers, and even poets to understand.

Bibliographical Note

The basic modern book on Poussin, on which much of my study is based, is Sir Anthony Blunt's *Nicolas Poussin* (2 vols., 1967: see Bibliography, p. 105). This is cited in the notes below simply as 'Blunt'. Blunt's companion *Critical Catalogue* of Poussin's works (1966) lists bibliography and other information for each picture. My quotations from Poussin's letters are based on the modern selection by Blunt (*Nicolas Poussin*, *Lettres et propos sur l'art*, 1964). Only when I have used Blunt's English translations have I footnoted the letters; but I trust that the year of the letter, always cited, will lead the curious reader quickly enough to the original. (The basic complete edition of the letters, with Poussin's archaic spellings, etc., is still that of Jouanny.)

In the notes below I often cite a study by Georg Kauffmann on *The Holy Family on the Steps* that appeared in his *Poussin-Studien* of 1960. This is cited as 'Kauffmann'. Part of his essay appeared in French in the *Colloques Poussin* of the same year. References in the notes are cited only by author, or, if there are multiple works by that author, by author and date. This method, I hope, combines brevity with clarity. Full titles and other bibliographical information are in each instance given in the Bibliography.

Notes

1. Catalogued by Blunt (1966, pp. 39 f., no. 53). In addition to his bibliography, see Bertin-Mourot, with a new engraving (reversed). Another version of our picture, evidently of high quality, in the Bertin-Mourot collection in Paris, was also accepted as autograph by Friedlaender (1966, p. 160) although he reproduced the Washington version. In recent times the latter has been all but unanimously considered the better or, usually, only original version. (Cf. notes 36 and 55.) The Washington picture has *pentimenti* in the cornices of the architecture where they meet the sky. There are also certain awkward features, particularly the over-large and rubbery hand of the Virgin.

2. This is part of the thesis of Kauffmann who, however, develops its implications to unbelievable lengths. (Cf. the criticisms by Białostocki and note 44 below.) Friedlaender nevertheless accepted a great deal of Kauffmann's theorizing about the perspective (1966, p. 163).

3. For an ideal introduction to Italian art of the seventeenth century, see Wittkower (1973); for patronage and background, Haskell. French cultural background is found in Maland. For Poussin in the context of French painting, see especially Thuillier; also Blunt (1970), and Châtelet-Thuillier (the latter is brief).

4. Mancini, I, p. 261; cf. Mahon (1946) who dates the passage 1627-8; Salerno (Mancini, II, p. 165, note 1204) says '1627 circa' (but in note 1208, '1626-27'). The context of the passage hardly allows the date to be later than 1627.

5. The inscription, added much later, reads in part: 'Ritratto Originale simigliantissimo di Monsr. Niccolò Possino fatto nello specchio di propria mano circa l'anno 1630, nella convalescenza della sua grave malattia, e lo donò al Cardinale de Massimi allora che andava da lui ad imparare il Disegno . . . ' (Original portrait, very like, of M. Nicolas Poussin made by his own hand while looking into the mirror in about 1630, while convalescing from his grave illness. Given to Cardinal Massimi when he came to Poussin to learn drawing . . .). Massimi was a friend of Poussin's old age (see p. 44).

6. Félibien, IV, p. 14, translated by Blunt, p. 224.

7. Quoted by Blunt, p. 208.

8. See Badt, 1968. For the picture of Painting, see D. Posner.

9. Pintard, p. 46; Colombier, p. 53.

10. Chantelou, pp. 66, 90; on another occasion, speaking of *The Martyrdom of St Erasmus* (p. 146), Bernini said that it was very beautiful – contradicting the opinion offered – and added 'che dentro ci era il fondo e il sodo del saper' (that within there was the foundation and solidity of knowledge).

11. Colombier, p. 52; the quotation from Jean Dughet is on his p. 49.

12. Briganti (pp. 165 f., no. 9) considers *The Triumph of Bacchus* to date *c.* 1623. I chose to illustrate it since it may well have influenced Poussin in his earliest Roman years, as Briganti mentions. Later pictures by Cortona, such as his well-known *Rape of the Sabines*, show the same characteristics developed more flamboyantly.

13. For the transfer of the *Bacchanale* and the *Worship of Venus* to the Ludovisi collection *c.* 1621, see Garas (p. 343, notes to nos. 29–31). By 1637 these two pictures were in Naples on their way to the King of Spain. Sandrart, a German artist and biographer who was in Rome from 1629–35, wrote of a visit to the Villa Aldobrandini: 'Once when, in the company of Pietro da Cortona, François Duquesnoy, sculptor, Poussin, Claude Lorraine, and others, I was able to see one of them, we all looked at it with great enjoyment and were of the unanimous opinion that Titian never executed anything more gay, charming, and beautiful, since art and nature are presented together with the greatest delicacy in every part' (Walker, p. 105). This was probably the *Bacchus and Ariadne*, now in the National Gallery, London, which remained in the Villa Aldobrandini together with the Bellini-Titian *Feast of the Gods*. For Poussin's copy of the latter, see Walker (pp. 106 ff. and fig. 32) and Blunt (1966, pp. 138 f., no. 201). Bellori (p. 412) states that Poussin copied the *Worship of Venus* (now in the Prado, Madrid) both in paint and in relief sculpture. Figures in Poussin's paintings show that he knew the others.

We associate rich coloration and a loose touch with Venetian art, and these qualities find their way into some of the early Poussins. Nevertheless, in trying to describe what Poussin got from his study of the *Worship of Venus*, Friedlaender years ago came up with the surprising formulation 'cool clarity'; this too can be found in Titian, and it was a quality that would have appealed most to Poussin (Mahon, 1964, p. 116).

14. The interpretation is by Panofsky (cf. Blunt, 1966, p. 82, 'Notes'). This picture inspired the title of the charming *roman fleuve* by Anthony

Powell, who evokes the painting in the opening paragraphs of the first volume, *A Question of Upbringing* (London, 1951).

15. For the inscription and its changing meaning in Poussin's own work see the brilliant essay by Panofsky, '*Et in Arcadia Ego*: Poussin and the Elegiac Tradition' (1955, pp. 295–320).

16. Poussin's letter on the Modes (24 November 1647) is translated and discussed by Blunt (pp. 225 ff. and *passim*). I agree with Mahon (1962, pp. 125 ff.; 1962a, pp. 150 ff.) that Poussin had no deep interest or belief in this theory as such; it was a metaphor that suited both his argument (which was to placate Chantelou – see note 63 below) and his practice. Further to the whole kind of thinking behind Poussin's use of these ideas, see Lee.

17. Translated by Blunt, p. 225. The word 'ratio' used by Blunt is expressed by Poussin as 'la raison', a difficult term to translate properly.

18. For Poussin and Stoicism, and his friends in Paris, see Blunt, Chapters IV and VI.

19. Translated by Blunt, p. 220.

20. See Colombier.

21. This is the undeveloped thesis of Van Helsdingen (p. 155), who points to Valerius Maximus as one of Poussin's probable sources. Further, see Blunt (pp. 294 f. and *passim*).

22. See Blunt, pp. 186 ff., and 205 f.

23. This picture, and others of the series, seems to be related to the Early Christian revival of the later sixteenth century when Counter-Reformatory Catholics attempted to cleanse themselves of time-encrusted impurities of thought and ritual and to return to the truth of the primitive Church. Many elements of Poussin's *Eucharist* (triclinia, lamp, etc.) are derived from a painting of the late sixteenth century by Otto Van Veen, Rubens's teacher, which was known from an engraving. (Cf. also Vanuxem.)

24. Reynolds, p. 256.

25. 'Poussin's real importance does not lie in the painting of Madonnas and Holy Families. In these peaceful, circumscribed themes he could not fully display his real strength, which consisted in developing a dramatic action or putting a fine edge on a moral, elegiac epigram; still less could he indulge his fondness for the antique and the Bacchic. In spite of this, Poussin painted a large number of Holy Families. Among them are some, like the Madonna on the Steps, and the Westminster Holy Family, in which the conception is of great beauty and dignity, but others, particularly the late ones for Chantelou [18] and Mme de Moutmort, are

almost terrifyingly harsh and stiff.' (Friedlaender, 1939, p. 20.) This is, essentially, an accurate statement. (The Westminster Holy Family is probably a *Rest on the Flight to Egypt*: Blunt, 1966, p. 45, no. 65.)

26. Blunt, Chapter V, discusses aspects of Poussin's religious ideas; cf. Mahon (1965, pp. 130 f.), and Pintard.

27. Mosse, p. 169.

28. Blunt, p. 171.

29. ibid., p. 167. The quotation that follows is from the same source. For the fusion of Stoicism and Christianity, see Abercrombie (note 35 below).

30. Mosse, p. 189; further, Pastor, XXIX, pp. 62–156; XXX, Chapter V; Harnack, pp. 523–4; and Abercrombie, 3 ff., 91 ff., and *passim*.

31. Blunt (p. 181) wrote: 'As regards subjects which refer directly to the Sacraments, the gathering of the Manna is a common symbol for the Eucharist, but all the rest refer to Baptism. The story of Noah and that of Moses striking the rock, which Poussin painted three times, combine the water of Baptism with the wood of the Cross, as also does the story of the exposing and finding of Moses (painted five times), in which the ark of bulrushes stands for the wood of the Cross. Of the others, the stories of Rebecca, Moses and the daughters of Jethro, and the crossing of the Red Sea all contain the element of water, the symbol of Baptism.

'An analysis of the New Testament themes leads to similar results. Poussin represents a number of subjects that were rare and archaic in his day, or represents them in an unusual manner, and there is a striking recurrence of the theme of Baptism or of subjects that allude to it allegorically.'

32. Cf. Hubala.

33. Blunt, p. 178.

34. Mosse, p. 173.

35. Abercrombie, p. 6 and *passim*. For St Augustine's influence on Montaigne and Descartes, see his Chapters II and III.

36. Kauffmann (p. 46 and note 40), and Von Einem (p. 43 and note 44) quote Edmond Bonnaffé, *Dictionnaire des amateurs français du XVII^e siècle* (Paris, 1884, p. 116). Otherwise all we know is what we are told by Félibien, who was in Rome at the time the painting was dispatched (see note 55 below). It was formerly believed that a *Bacchanale in Front of a Temple* (now lost) was also painted for Hennequin. It seems, however, that the patron was a different M. du Fresne (Blunt, 1966, pp. 100 f., no. 140; 1967, Pl. 205, shows a copy of the *Bacchanale*).

37. I tend to agree, therefore, with Mahon (1967; see also Mahon, 1965, pp. 125 ff.). Nevertheless, there are certain paintings that do reflect the tastes or desires of a specific patron, and Poussin thought of certain subjects as fitting for certain patrons – witness his sneering comment that a Bacchic subject would be 'plaisant pour Monsieur Scarron', a man Poussin despised (7 February 1649).

38. Friedlaender, 1966, pp. 161, 163. Here we approach the problems dealt with by Kauffmann in a different manner.

39. Blunt (p. 264) claims that this is the first instance of Poussin's turning to one of Raphael's Roman *Madonnas* for inspiration; but Raphael had been an increasing source for Poussin's ideas for over a decade, and it is doubtless the lack of Madonnas and Holy Families in Poussin's earlier *oeuvre* that makes this initial borrowing so late. Von Einem (pp. 31–5 and *passim*) makes much of the connection with Raphael, comparing and contrasting the two artists.

40. Already pointed out by Blunt (1938–9, p. 56, note 2). The relationship to the *Madonna del Sacco* has long been noted. Can it be fortuitous that Poussin used the pose of an ancestor of Christ for a figure of Joseph, whose genealogy (in Matthew) furnished Jesus with his ancestry in the Tribe of David?

41. This sense of atmosphere reminds me of certain works by Vermeer; I was happy to discover that Denis Mahon described the Chantelou *Self-Portrait* [1] in somewhat similar terms: ' . . . it possesses . . . certain passages of colour and particularly of light being treated with an extraordinary sensitiveness which is the more effective for not proclaiming itself too obviously, for being kept under control in a way not too dissimilar from that which we experience with Vermeer' (1967, p. 593).

42. Blunt, pp. 183–4. For the antique studies, see his p. 141.

43. Mâle, 1951, pp. 309 ff., discusses the popularity of the Holy Family as it developed from a theme of Franciscan meditation (for which see Mâle, 1949, pp. 49 f.).

44. See Mâle, 1951, pp. 312 ff., and Blunt, pp. 182 f. Actually the cult of Joseph had begun even earlier: see D'Ancona (p. 45 and note 18). Francis de Sales dedicated one of his *Entretiens spirituels* to Joseph, whose feast day was established in 1621 as one to be celebrated by the entire Church (Mâle, 1951, p. 315). The significance of the compasses was first pointed out by Blunt (1938–9, pp. 55 f.); further, cf. Kauffmann, pp. 50 ff. Kauffmann's controversial symbolic-perspective arguments are summarized and criticized by Białostocki; see also Blunt (1961), Ettlinger,

and Van Helsdingen (pp. 173 f.), all of whom oppose many or most of Kauffmann's conceptions.

45. Palladio, xxv, p. 99; cf. Blunt, p. 236 and fig. 188. See also the the temple in Palladio, p. 108.

46. Blunt (1961, p. 285) cites Kauffmann (p. 39) but actually the latter seems to be of the opinion that the architecture symbolizes the celestial city (also the opinion of Van Helsdingen – see note 68 below). Kauffmann did, however, also make the attractive suggestion that these are the same steps that Mary walked up as a child of three – i.e., of the Temple.

The comparison with *Peter and John Healing* was made by Blunt.

An etching of *The Holy Family with Elizabeth and John* by Elisabetta Sirani, after a composition by her father (Bartsch, xix, 8), was kindly brought to my attention by Ann S. Harris. In it the figures are seen before a long flight of steps, some seven of which are visible (P. & D. Colnaghi Co. Ltd, 'Art in XVIIth Century Italy', catalogue of an exhibition held from 13 April to 13 May 1972, no. 73, Plate XXVIII). If the seven steps are not shown by chance, they may be symbolic, and it is at least worth pointing out that the *Peter and John Healing*, previously mentioned, shows a Temple with seven steps. Our *Holy Family* has two steps in the fore-ground, and five in the back, although the numerical significance may well be fortuitous. For the symbolism of the number seven, see Mâle (1948, p. 11), and Ezekiel 40, xxii and xxvi.

47. Blunt (1961); cf. Kauffmann, *passim*. The latter (p. 50) quotes Alanus ab Insulis: 'Deus mundi elegans Architectus.' In our picture, Joseph's illuminated foot, parallel to the T-square, may even symbolize the unit of measure or module, as my friend and student Charlotte Rice pointed out; the French unit of measurement was at that time a foot (*pied*).

48. An introduction to right and left symbolism is in Panofsky (1953, pp. 133, 147, and note 2). For example, 'the Good Thief and the Church are invariably on the right of the Cross, and the Bad Thief and the Synagogue on its left, as explicitly stated by Thomas Aquinas in *De sacramento altaris* XXXI, and St Augustine in *In Septimun Caput Johannis*, XXXI' (cited by Johannes Molanus, *De Picturis et Imaginibus Sacris*, Louvain, 1570, IV, 4).

49. Lavin, 1955, pp. 86-93 and *passim*; 1961, *passim*. For Elizabeth in art, see also Wirth.

50. Lavin, 1961, p. 324; in note 26 she cites Giulio Romano's *Madonna della Catina* in Dresden, in which Jesus stands in a pan into which the

Baptist pours water. The other Holy Families by Poussin painted in this period also show the group near, or in front of a body of water (Blunt, Pls. 208-11). Cf. my note 31 above. Raphael's Madonnas with St John (*del Prato*, *del Cardellino*, and '*La Belle Jardinière*') all show the group before a body of water, as does Michelangelo in the Doni *Madonna* (see D'Ancona, pp. 47 and 50, note 68).

It is also worth recalling that Catholic liturgy is perfumed with phrases such as 'the living waters' of God's grace; the Bible echoes with these sayings – 'The fear of the Lord is the fountain of life for the man who would escape the snares of death' (Proverbs 14, xxvii); 'Then he showed me the river of the water of life . . . flowing from the throne of God' (Revelations 22, i). For the Fathers, Mary was herself a metaphorical fountain (see Migne, CCXIX, 143 and 508, and Hirn, p. 447); cf. Van Helsdingen, p. 174 and note 96. Panofsky (1953, p. 137) claimed that in earlier northern painting the most typical symbols of the Virgin's purity were the 'fountain of gardens' and the 'well of living waters' of the Song of Songs. (Cf. the print by Goltzius in Guldan, fig. 85; for Mary as the Bride of the Song of Songs, cf. Mâle, 1949, pp. 212 ff.)

51. See note 31 above. In addition to spiritual rebirth, Poussin may have thought that the Church also needed a great new leader: in one of his letters, referring to the mortal illness of Urban VIII, he states: 'It is said here that His Holiness is ill. If he is taken from us, God give us a better.' But a later letter says 'God grant that we shall be better governed in the future than in the past,' and thus both references are probably only to the temporal aspect of the Pope's ambiguous dual authority (translations from Blunt, p. 178).

52. I print here the King James version.

53. Quoted by Willey, p. 61, and note 1; he cited Farrar, *History of Scriptural Interpretation*, 1886, p. 237. Cf. Kuhns, pp. 23-36. Montagu (p. 311) recently pointed out that 'the whole tradition of allegorical Biblical interpretation . . . was still very much alive in the seventeenth century, in the writing of spiritual literature, and in the preaching of sermons . . . ' She went on to recall that in a lecture of 1671 on Poussin's *Ecstasy of St Paul*, Le Brun made it clear that he considered painting to be mute theology (Montagu, p. 331). For Counter-Reformatory paintings as mute sermons, cf. Hibbard.

54. See Guldan. Panofsky (1953, p. 144) explained that the apple in the Melbourne Madonna, a copy after Van Eyck, 'beautifully fresh and intact, suggests by this very intactness the *gaudia Paradisi* lost through the

Fall of Man but regained, as it were, through Mary, the "new Eve".'
Moreover, Jesus was often regarded as the new Adam. Further afield,
the orb carried by rulers is called in some languages an apple (*Reichsapfel*).
This is also the orb carried by Christ in many representations of the
Salvator Mundi. In some Renaissance paintings the apple associated with
the Christ child, because of its association with the Tree of Knowledge,
seems to symbolize the death of the physical body and hence the salvation
that follows (Friedmann, 1947). Since in many other pictures John and
Christ play with a bird (goldfinch) that symbolizes foreknowledge of the
Passion and Resurrection, this meaning may be potentially relevant to our
picture (see Friedmann, 1946). It seems typical of the allusiveness of our
painting that the simple transfer of an apple inevitably implies many or
most of these things. (For further apple lore, see Schapiro, note 36 and
passim.)

55. The only source for the date of the picture is the well-informed
Félibien, who was in Rome at the time and even studied with Poussin.
Félibien wrote: 'Outre le dernier des sept Sacramens [*Marriage*] qu'il
envoya au commencement de l'année 1648, il finit pour Monsieur du
Frêne Annequin une Vierge assise sur des degrez, qui est presentement
à l'Hotel de Guise . . . ' (p. 59). Given this statement, which is followed by
the titles of some other works of 1648, we are entitled to imagine that the
picture had been begun earlier and was then postponed because of pres-
sure from Chantelou.

56. Friedlaender, 1939, p. 25, no. 45; *verso*: no. 77 (sketch of St John
Baptising, presumably for the second Sacraments, painted in 1646). Dis-
cussed by Kauffmann (p. 41); Blunt had doubts about its originality in
1961 but apparently accepted it in 1966 (p. 40, 'Drawings', 1). Poussin's
drawings were often copied and it is not at all sure that we can tell in each
case the original from the copy. (This and the following drawings are also
discussed by Von Einem, *passim*.)

57. Friedlaender (1939, p. 25, no. 46): 'This drawing was probably
executed by Poussin shortly before the paintings; but it is just possible
that it may be a very clever imitation or a copy.' Discussed by Kauffmann,
pp. 43 f. Illustration 50 (Friedlaender, 1939, p. 26, no. 49) is clearly an
offshoot from drawings that are more strictly for our picture.

58. St John as an infant hermit – as the bowl and staff make him out to
be here – was a familiar iconographical theme in Italian art from the mid-
fourteenth century on (cf. Lavin, 1955, p. 89; 1961, *passim*).

59. Kauffmann, pp. 42 f., dates the fragment at the left of the sheet *c*. 1645 because of its connection with *Ordination* and a *Christ* in the Louvre. Blunt (1961) considered the sketch as possibly for Christ in *Penance*, finished June 1647. The *recto* (Friedlaender, 1949, no. 145) has a *Rinaldo and Armida* unconnected with any known painting but dated by Friedlaender to the late 1640s by technique (p. 23).

60. Friedlaender, 1939, pp. 25 f., no. 47. A copy in Bayonne was owned by Chantelou. Kauffmann's reconstruction of the various background projects (pp. 44 ff. and figs. 6–8) was questioned by Blunt (1961).

61. Illustration 49 (Friedlaender, 1939, p. 26, no. 48) is not listed by Blunt (1966, p. 41, no. 55) – evidently inadvertently. Illustration 50 corresponds to Friedlaender no. 49 (see note 57 above).

62. Further to Poussin's preparatory procedures, see the instructive paper by Wittkower (1963).

63. Friedlaender, 1939, no. 52. The date is derived from other drawings on the sheet (no. 25, a preliminary drawing for the *Moses* of 1649 in the Hermitage; and Friedlaender, 1953, nos. 166–8, for a *Rape of Europa* first mentioned in August of 1649). These furnish more than adequate support for his date; but the stylistic affinities with the *Marriage* of 1647–8 seem to me equally convincing, and the relationship to our *Holy Family*, noted by Friedlaender, does not call for the later date. In fact the drawing closest to this *Madonna* is for the *Judgment of Solomon* (Friedlaender, 1939, no. 32), painted in 1649 for the banker Pointel. As we have seen, such preparatory drawings often antedate the finished picture. Thus these drawings, while possibly of 1649, might fall more reasonably into 1647–8. I am tempted to consider the *Madonna Enthroned* a first study for Chantelou's *Holy Family* [18], which assumed its final composition only several years later (Blunt, 1966, pp. 41 f., no. 56). In a letter of 22 December 1647 Poussin writes: ' . . . as for the *Virgin* you want me to do, beginning tomorrow I will rack my brain in order to find some new idea and new composition (*nouveau caprice et nouvelle invention*) to execute in its own time.' He goes on to say: 'all this to stop that cruel jealousy which makes a fly look to you the size of an elephant.' The reference is to Chantelou's disappointment with his *Baptism* in comparison with another picture, *The Finding of Moses*, which Poussin had painted earlier for Pointel. In response to Chantelou's first signs of disappointment Poussin wrote the now famous letter on the Modes (see above and note 16). Thus, in an effort to placate Chantelou, Poussin may indeed have tried a novel

composition for his *Holy Family* during the winter of 1647–8. (Perhaps connected with this image of the Virgin enthroned is Poussin's habit of referring to Chantelou's *Holy Family* simply as a 'Vierge'.)

64. Badt (1969, p. 500) recognized this strange aspect of the faces, calling them mask-like, and emphasized the quality of the figures as being, like the masks used in a sacred rite, 'there and yet at the same time not there'; Badt related this to the inherent ambivalence of incarnate deities.

65. Costello, p. 22, with references.

66. K. Posner, p. 131, note 64. The interpretation of *petrus* (rock) in the Bible as Christ was a familiar conceit, which is related to Christ's own pun on the name of Peter (*Tu es Petrus et super hanc petram aedificabo ecclesiam meam* – You are Peter, the Rock; and on this rock I will build my church . . . ' – Matthew 16, xviii). There are various 'Madonnas of the Rock' (*Madonna del Sasso*) in Renaissance art. Ours is not one of them, but Poussin may nonetheless have been aware of the significance. For the sometimes related 'Madonna of Humility', see Meiss, Chapter VI, and D'Ancona, p. 44, note 14.

67. Andresen, no. 135 (without illustration). Shown with the inscription by Bertin-Mourot, p. 4. The very name 'Jesus' is derived from the Greek form of the Hebrew word 'Joshua', meaning 'the Lord is Salvation'. It was this name that, according to the Gospel writers, was bestowed upon the infant Christ by divine command in fulfillment of Isaiah's prophesy.

For the hidden God, cf. Wind, 1968, Chapter XIV.

68. Kauffmann and Van Helsdingen, as we have noted, see the architecture itself as paradise (note 46 above). This is of course possible; I think my interpretation fits the evidence better. I must insist, however, on the relative fluidity of these ideas since we are discussing a painting by an artist and not a treatise by a theologian (or an essay by an art historian). Poussin himself may not have sorted out all these related images in his mind, rational though he was.

69. '*Nubes enim pro Caelo ponuntur*' (Opera omnia, XI, 94, cited by H. Kauffmann, p. 158, note 100). Kauffmann also cited Psalm 89:7, '*Quoniam qui in Nubibus aequabitur Domino*,' which is translated in the King James version (89. vi): 'For who in the heaven can be compared unto the Lord?' The usual sourcebook for symbolism used by painters in this period, Cesare Ripa's *Iconologia*, lists clouds as a symbol of 'divine wisdom' (H. Kauffmann, p. 158, note 104; cf. also his p. 159 and note 105).

70. Kris, Chapter 13, and pp. 60 ff., 167, 197 ff., 253 ff., etc.

71. This was Freud's famous basic formulation, first published in *Studies on Hysteria* (SE II, pp. 173 f.). The idea, expressed by the word 'Überdeterminiert', which Breuer called Freud's discovery (p. 212), is first used on p. 263. (Cf. the note to SE II, p. 212.) The idea was developed with references to dreams in Freud's *Interpretation of Dreams* (SE IV–V, pp. 282 ff., 202 f., 306 ff., and *passim*, for dreams; cf. also pp. 480, 569). For the artist, Kris, p. 254: 'An action (including an act of producing symbols) is said to be overdetermined when it can be construed as the effect of multiple causes. Such overdetermination is characteristic of almost all purposive action; but it is especially marked when the psychic level from which the behavior derives is close to the primary process. Words, images, fancies come to mind because they are emotionally charged; and the primary process exhibits to a striking degree the tendency to focus in a single symbol a multiplicity of references and thereby fulfil at once a number of emotional needs. This is most clearly exemplified in the dream, but can be traced as well in the production of poetry, as was shown, for instance, in John Livingston Lowes's *Road to Xanadu*. Overdetermination and consequent ambiguity is central to the understanding of poetry as self-expression – i.e., as the distinctive product of an individual artist.'

The problem of layers of meaning and of how deeply Poussin's paintings should be interpreted arose almost immediately after Poussin's death. See the revealing essay by Montagu, especially pp. 330 ff., and note 53 above.

72. Richard Crashaw entitled his collection of divine and other poems, published in 1646, *Steps to the Temple*.

73. Cf. Armellini, II, pp. 1375–6. One of these churches, Santa Maria della Scala in Trastevere, would have been familiar to Poussin. A second, Santa Maria Scala Coeli at Tre Fontane, just outside Rome, was hardly less well known, and was often visited.

74. For the relief, see Calì; for the Casa Buonarroti, Procacci.

75. The idea of a stairway reappears in Robert Bellarmine's *Scala da salire con la mente a dio . . .* , of 1614. The great Jesuit controversialist here picks up a common idea that, although not specifically relevant for our picture, illustrates the currency of the image. For John Climacus, see Martin. Jacob's ladder was depicted, among other places, in the Gesù (cf. H. Kauffmann, pp. 157 f.).

76. Migne, PL XXXIX, col. 1991, 2: 'Facta est Maria fenestra coeli, quia per ipsam Deus verum sudit saeculis lumen. Facta est Maria scala

coelestis; quia per ipsam Deus descendit ad terras, ut per ipsam homines ascendere mererentur ad coelos; ipsis enim licebit ascendere illuc, qui Deum crediderint ad terras per verginem Mariam descendisse. Facta est Maria restauratio feminarum; . . . ' The quotation figures largely in Van Helsdingen's interpretation (pp. 175 f.; he simply cites a handbook and does not even mention Augustine). Independently, Cali used other texts with rich supplementary material to explicate Michelangelo's *Madonna of the Stairs*.

Migne uses the Paris edition of 1683 for his texts of Augustine's Sermons. Our Sermon, no. CXXII of the Appendix, is clearly a later production, probably medieval. But I think we can assume that at the time of Poussin's picture, this sermon was commonly accepted as Augustine's.

For a visual use of a 'celestial' ladder on a tomb from the Catacomb of Priscilla, see Marucchi (p. 41).

77. Migne, PL LXV, col. 899; cf. St Bernard of Clairvaux, PL CLXXIV, col. 1016. For the Savonarolan interest in this image, see Cali, from whom I translate the poem that follows; see also Wind, 1960, p. 79 and note 3.

There is also an old tradition of Mary as the 'altar of heaven', commemorated by the church on the Capitol, Santa Maria in Aracoeli.

78. A painting by Vecchietta in Siena shows the Madonna helping souls up a ladder to heaven (cited by K. Posner, p. 122, note 8).

79. One of the chief aims of the Jansenists (see p. 44) was the restoration of Augustine's doctrine of grace, which had been obfuscated by medieval Aristotelianism. Jansenist or no, Poussin might well have been drawn to Augustine through this vital contemporary French movement. Whether from Jansenists or elsewhere, these ideas were in the air. Cf. Abercrombie, pp. 7–15 and *passim*; further, Mosse, p. 188 and *passim*, and Cragg, pp. 25 f.

80. Augustine, *De Musica*, translated by Kuhns, p. 32 and *passim*, who is also the source of the quotation that follows (his p. 31).

Bibliography

ABERCROMBIE, NIGEL, *Saint Augustine and French Classical Thought*, Oxford, 1938.

ANDRESEN, ANDREAS, *Nicolaus Poussin, Verzeichniss der nach seinen Gemälden gefertigten gleichzeitigen und späteren Kupferstiche*, Leipzig, 1863.

ARMELLINI, MARIANO, *Le chiese di Roma . . .* , ed. C. Cecchelli, Rome, 1942, 2 vols.

BADT, KURT, ' "Je n'ai rien négligé" ', *Festschrift für Werner Gross . . .* , Munich, 1968, pp. 195-215.

—, *Die Kunst des Nicolas Poussin*, Cologne, 1969, 2 vols.

BELLORI, GIOVANNI PIETRO, *Le vite de' pittori . . .* , Rome, 1672.

BERTIN-MOUROT, THÉRÈSE, 'Poussin et le blason des Guénégands', *Bulletin de la Société Poussin*, IV, 2, 1967.

BIAŁOSTOCKI, JAN, review of G. Kauffmann (*q.v.*), *Art Bulletin*, XLIII, 1961, pp. 68-72.

BLUNT, ANTHONY, 'Blake's "Ancient of Days" ', *Journal of the Warburg Institute*, II, 1938-9, pp. 53-63.

—, review of G. Kauffmann (*q.v.*), *Burlington Magazine*, CII, 1961, p. 285.

—, *The Paintings of Nicolas Poussin. A Critical Catalogue*, London, 1966.

—, *Nicolas Poussin* (The A. W. Mellon Lectures in the Fine Arts, 1958, National Gallery of Art, Washington, D.C.), New York, 1967, 2 vols.

—, *Art and Architecture in France 1500 to 1700* (Pelican History of Art), 2nd edition, Harmondsworth, 1970.

—, *see also* Friedlaender and Poussin.

BREUER, JOSEPH – *see* Freud.

BRIGANTI, GIULIANO, *Pietro da Cortona . . .* , Florence, 1962.

CALÌ, MARIA, 'La "Madonna della Scala" di Michelangelo il Savonarola e la crisi dell'umanesimo', *Bollettino d'arte*, LII, 1967 [1970], pp. 152-66.

CHANTELOU, PAUL FRÉART, SIEUR DE, *Journal du voyage du Cav. Bernini en France*, ed. L. Lalanne, Paris, 1885.

CHÂTELET, ALBERT, and JACQUES THUILLIER, *French Painting from Fouquet to Poussin*, Cleveland, 1963.

COLOMBIER, PIERRE DU, 'Poussin et Claude Lorrain', *Nicolas Poussin* ('Colloques Poussin'), ed. A. Chastel, I, Paris, 1960, pp. 47-56.

COSTELLO, JANE, 'Poussin's *Annunciation* in London', *Essays in Honor of Walter Friedlaender*, (*Marsyas*, Supplement II), Locust Valley, N.Y., 1965, pp. 16-22.

—, *see also* Friedlaender.

CRAGG, GERALD R., *The Church in the Age of Reason 1648-1789* (The Pelican History of the Church, 4), Harmondsworth, 1960.

D'ANCONA, MIRELLA LEVI, 'The *Doni Madonna* by Michelangelo: An Iconographical Study', *Art Bulletin*, L, 1968, pp. 43-50.

ETTLINGER, LEOPOLD, review of G. Kauffmann (*q.v.*), *Kunstchronik*, 1961, pp. 196-9.

FÉLIBIEN, ANDRÉ, *Entretiens sur les vies et sur les ouvrages des plus excellents peintres . . .*, IV, Paris, 1725.

FREUD, SIGMUND, *Studies on Hysteria* (with J. Breuer), Standard Edition, II, London, 1955.

—, *The Interpretation of Dreams* (SE IV-V), London, 1958.

FRIEDLAENDER, WALTER, *The Drawings of Nicolas Poussin, catalogue raisonné* (Studies of the Warburg Institute, 5), I, *Biblical Subjects*, in collaboration with Rudolf Wittkower and Anthony Blunt, London, 1939.

—, ibid., II, *History, Romance, Allegories*, in collaboration with Anthony Blunt and Rudolf Wittkower, London, 1949.

—, and Anthony Blunt, ibid., III, *Mythological Subjects*, in collaboration with Ellis K. Waterhouse and Jane Costello, London, 1953.

—, *Nicolas Poussin . . .*, New York [1966].

FRIEDMANN, HERBERT, *The Symbolic Goldfinch . . .* (The Bollingen Series, VII), New York, 1946.

—, 'The Symbolism of Crivelli's Madonna and Child Enthroned . . . in the National Gallery', *Gazette des Beaux-Arts*, XXXII, 1947, pp. 65-72.

GARAS, KLARA, 'The Ludovisi Collection of Pictures in 1633', *Burlington Magazine*, CIX, 1967, pp. 287-9, 339-48.

GULDAN, ERNEST, *Eva und Maria . . .*, Cologne, Graz, 1966.

HARNACK, ADOLF, *Outlines of the History of Dogma*, Boston, 1957.

HASKELL, FRANCIS, *Patrons and Painters*, London, 1963.

HIBBARD, HOWARD, '*Ut picturae sermones*: The First Painted Decorations of the Gesù', *Baroque Art: The Jesuit Contribution*, ed. R. Wittkower and I. Jaffe, New York, 1972, pp. 29–49.

HIRN, YIRO, *The Sacred Shrine*, Boston, 1957.

HUBALA, ERICH, 'Roma sotterranea barocca', *Das Münster*, XVIII, 1965, pp. 157–70.

KAUFFMANN, GEORG, *Poussin-Studien*, Berlin, 1960 (cited as 'Kauffmann').

KAUFFMANN, HANS, *Giovanni Lorenzo Bernini . . .*, Berlin, 1970.

KRIS, ERNST, *Psychoanalytic Explorations in Art*, New York, 1964.

KUHNS, RICHARD, *Structures of Experience*. Essays on the Affinity between Philosophy and Literature, New York, London, 1970.

LAVIN, MARILYN ARONBERG, 'Giovannino Battista: A Study in Renaissance Religious Symbolism', *Art Bulletin*, XXXVIII, 1955, pp. 85–101.

—, 'Giovannino Battista: A Supplement', ibid., XLIII, 1961, pp. 319–26.

LEE, RENSSELAER W., *Ut Pictura Poesis. The Humanistic Theory of Painting*, New York, 1967.

MAHON, DENIS, 'Nicolas Poussin and Venetian Painting: A New Connexion', *Burlington Magazine*, LXXXVIII, 1946, pp. 15–20, 37–42.

—, 'Poussiniana . . . ,' *Gazette des Beaux-Arts*, LX, 1962, pp. 1–138 (also published as a separate monograph).

—, 'Nicolas Poussin', *L'Ideale classico del seicento in Italia e la pittura di paesaggio*, catalogue, Bologna, 1962, pp. 150–220 (cited as 'Mahon 1962a').

—, 'A Plea for Poussin as a Painter', *Walter Friedlaender zum 90. Geburtstag*, Berlin, 1965, pp. 113–42.

—, 'Poussin and his Patrons', *Burlington Magazine*, CIX, 1967, pp. 304–8 (with a reply by Ann S. Harris), 591–3.

MALAND, DAVID, *Culture and Society in Seventeenth-Century France* (Studies in Cultural History, ed. J. R. Hale), London, 1970.

MÂLE, ÉMILE, *L'Art religieux du XIII^e siècle en France*, 8th edition, Paris, 1948.

—, *L'Art religieux de la fin du moyen age en France . . .*, 5th edition, Paris, 1949.

—, *L'Art religieux de la fin du XVI^e siècle, du XVII^e siècle . . .*, 2nd edition, Paris, 1951.

MANCINI, GIULIO, *Considerazioni sulla pittura . . .*, I, ed. A. Marucchi, Rome, 1956; II, notes by L. Salerno, 1957.

MARTIN, JOHN R., *The Illustrations of The Heavenly Ladder of John Climacus* (Studies in Manuscript Illumination, 5), Princeton, 1954.

MARUCCHI, ORAZIO, 'Relazione degli scavi eseguiti nel cimitero di Priscilla . . . ', *Nuovo bollettino di archeologia cristiana*, XII, 1906, pp. 5-65.

MEISS, MILLARD, *Painting in Florence and Siena after the Black Death*, Princeton, 1951.

MIGNE, JACQUES PAUL, *Patrologiae cursus completus . . .*, Series Latina [PL], Paris, 1844-80, 221 vols.

MONTAGU, JENNIFER, 'The Painted Enigma and French Seventeenth-Century Art', *Journal of the Warburg and Courtauld Institutes*, XXXI, 1968, pp. 307-35.

MOSSE, G. L., 'Changes in Religious Thought', *The New Cambridge Modern History*, IV, Cambridge, 1970, pp. 169-201.

PALLADIO, ANDREA, *I quattro libri dell'architettura . . .*, Venice, 1570.

PANOFSKY, ERWIN, *Early Netherlandish Painting*, Cambridge, Mass., 1953, 2 vols.

—, '*Et In Arcadia Ego*: Poussin and the Elegiac Tradition', *Meaning in the Visual Arts*, New York, 1955; Harmondsworth, 1971, pp. 295-320.

PASTOR, LUDWIG VON, *The History of the Popes*, XXIX, London, 1938; XXX, London, 1940.

PINTARD, RENÉ, 'Rencontres avec Poussin', *Nicolas Poussin* ('Colloques Poussin'), ed. A. Chastel, I, Paris, 1960, pp. 31-46.

POSNER, DONALD, 'The Picture of Painting in Poussin's *Self-Portrait*', *Essays in the History of Art Presented to Rudolf Wittkower*, London, 1967, pp. 200-203.

POSNER, KATHLEEN W.-G., 'Notes on S. Maria dell'Anima', *Storia dell'arte*, VI, 1970, pp. 121-38.

POUSSIN, NICOLAS, *Correspondance de N.P.*, ed. C. Jouanny (*Archives de l'art français*, N.S., 5), Paris, 1911.

—, *Lettres et propos sur l'art*, ed. A. Blunt, Paris, 1964.

PROCACCI, UGO (ed.), *La Casa Buonarroti a Firenze*, Milan, 1967.

REYNOLDS, SIR JOSHUA, *Discourses on Art*, ed. R. W. Wark, San Marino, California, 1959.

SCHAPIRO, MEYER, 'The Apples of Cézanne: An Essay on the Meaning of Still-life,' *The Avant-Garde, Art News Annual*, XXXIV, 1965, pp. 35-53.

THUILLIER, JACQUES, 'Poussin et son temps', *Nicolas Poussin et son temps*, Musée des Beaux-Arts de Rouen, 1961, pp. lx–lxxxix.

—, *see also* Châtelet.

VAN HELSDINGEN, H. W., 'Aantekeningen bij de Ikonografie van Poussin', *Simiolus*, III, 3, 1968–9, pp. 153–79.

VANUXEM, JACQUES, 'Les "Tableaux Sacrés" de Richeome et l'iconographie de l'eucharistie chez Poussin', *Nicolas Poussin* ('Colloques Poussin'), ed. A. Chastel, I, Paris, 1960, pp. 151–62.

VON EINEM, HERBERT, 'Poussin "Madonna an der Treppe"', *Wallraf-Richartz-Jahrbuch*, XXVIII, 1966, pp. 31–48.

WALKER, JOHN, *Bellini and Titian at Ferrara*, New York, 1956.

WILLEY, BASIL, *The Seventeenth-Century Background*, Harmondsworth, 1962.

WIND, EDGAR, 'Michelangelo's Prophets and Sibyls', *Proceedings of the British Academy*, LI, 1960, pp. 47–84.

—, *Pagan Mysteries in the Renaissance*, New York, 1968.

WIRTH, KARL-AUGUST, 'Elisabeth', *Reallexikon zur deutschen Kunstgeschichte*, IV, Stuttgart, 1958, pp. 1426–31.

WITTKOWER, RUDOLF, 'The Role of Classical Models in Bernini's and Poussin's Preparatory Work,' *Studies in Western Art* (Acts of the 20th International Congress of the History of Art), III, Princeton, 1963, pp. 41–50.

—, *Art and Architecture in Italy: 1600 to 1750* (Pelican History of Art), 3rd edition, Harmondsworth and Baltimore, 1973.

—, *see also* Friedlaender.

List of Illustrations

Color plate and title page: *The Holy Family on the Steps*. By Poussin, 1648. Oil on canvas, 68·9 x 97·5 cm. Washington, National Gallery of Art, Samuel H. Kress Collection. (Photo: Gallery.)

1. *Self-Portrait*. By Poussin, 1649–50. Paris, Louvre. (Photo: Agraci.)

2. *Self-Portrait*. By Poussin, *c*. 1630. Pen and wash. London, British Museum. (Photo: Museum.)

3. *St Margaret of Cortona*. By Lanfranco, 1621. Florence, Palazzo Pitti. (Photo: Gabinetto Fotografico Nazionale.)

4. St Peter's, the crossing with baldachin and St Longinus by Bernini, 1624–33 and 1629–38. (Photo: Alinari.)

5. *The Death of Germanicus*. By Poussin, 1627. Minneapolis, Institute of Arts. (Photo: Museum.)

6. *The Martyrdom of St Erasmus*. By Poussin, 1628–9. Vatican, Pinacoteca. (Photo: Museum.)

7. *The Triumph of Bacchus*. By Pietro da Cortona, *c*. 1623. Rome, Museo Capitolino. (Photo: Oscar Savio.)

8. *Bacchanal: The Andrians*. By Titian, 1519. Madrid, Museo del Prado. (Photo: Anderson.)

9. *Diana and Endymion*. By Poussin, *c*. 1632. Detroit, Institute of Arts. (Photo: Courtesy of the Detroit Institute of Arts.)

10. *The Arcadian Shepherds*. By Poussin, *c*. 1630. Chatsworth. (Photo: Courtesy of the Trustees of the Chatsworth Settlement.)

11. *A Dance to the Music of Time*. By Poussin, *c*. 1639. London, The Wallace Collection. (Photo: Museum.)

12. *St John on Patmos*. By Poussin, *c*. 1644–5. Chicago, The Art Institute. (Photo: Courtesy of the Art Institute of Chicago.)

13. *Landscape with the Body of Phocion Transported to Megara*. By Poussin, 1648. Ludlow, Earl of Plymouth Collection. (Photo: Villani, Bologna.)

14. *Landscape with the Ashes of Phocion Collected by His Widow*. By Poussin, 1648. Knowsley, Earl of Derby Collection. (Photo: Villani, Bologna.)

15. *Eucharist.* By Poussin, 1647 (Second Sacraments Series). Edinburgh, National Gallery of Scotland, on loan from the Duke of Sutherland. (Photo: Annan.)

16. *Marriage.* By Poussin, 1647-8 (Second Sacraments Series). Edinburgh, National Gallery of Scotland, on loan from the Duke of Sutherland. (Photo: Annan.)

17. *Madonna Enthroned with Joseph and Angels.* By Poussin, 1647-9. Pen and bistre wash. Stockholm, National Museum. (Photo: Museum.)

18. *The Holy Family.* By Poussin, 1653-5. Leningrad, Hermitage.

19. *The Holy Family on the Steps*, detail. (Photo: Henry Beville.)

20. *The Aldobrandini Wedding.* Roman fresco. Vatican Museum. (Photo: Alinari.)

21. *The Canigiani Holy Family.* By Raphael, 1507. Munich, Alte Pinakothek. (Photo: Museum.)

22. *Holy Family with Saints.* By Palma Vecchio, *c.* 1520. Glasgow, Art Gallery and Museum. (Photo: Museum.)

23. *The Holy Family on the Steps*, detail. (Photo: Henry Beville.)

24. *The 'Madonna of the Fish'*, detail. By Raphael, *c.* 1513. Madrid, Museo del Prado. (Photo: Museum.)

25. *The Holy Family on the Steps*, detail.

26. *Putto*, from the tomb of Ferdinand Van den Eynde. By François Duquesnoy, 1633-40. Rome, Santa Maria dell'Anima. (Photo: G.F.N.)

27. *The Persian Sibyl.* By Michelangelo, 1511-12. Vatican, Sistine Chapel. (Photo: Anderson.)

28. *The Holy Family on the Steps*, detail. (Photo: Henry Beville.)

29. *The Madonna del Sacco*, detail. By Andrea del Sarto, 1525. Florence, SS. Annunziata, cloister. (Photo: Alinari.)

30. *Naason.* By Michelangelo, 1511-12. Vatican, Sistine Chapel ceiling, detail. (Photo: Anderson.)

31. *The Holy Family on the Steps*, detail.

32. *Antique Studies.* By Poussin, 1630-40. Paris, Musée du Louvre, (coll. École des Beaux-Arts). (Photo: Museum.)

33. *The Adoration of the Magi*, detail. By Poussin, 1633. Dresden, Staatliche Kunstsammlungen. (Photo: Villani, Bologna.)

34. *The Rest on the Flight into Egypt.* By Orazio Gentileschi, *c.* 1626. Vienna, Gemäldegalerie. (Photo: G.F.N.)

35. *The Holy Family in the Temple.* By Poussin, *c.* 1640-43. Chantilly, Musée Condé. (Photo: Giraudon.)

36. *The Holy Family Visited by the Family of John the Baptist.* Copy after Federico Barocci. (Original, now largely destroyed, *c.* 1588–93). New York, Metropolitan Museum. (Photo: Museum.)

37. *Flight into Egypt.* By Guido Reni, 1630s. Leningrad, Hermitage. (Photo: Museum.)

38. *The Flagellation of St Andrew.* By Domenichino, 1608. Rome, San Gregorio Magno, Cappella di Sant'Andrea. (Photo: Alinari.)

39. *St Cecilia Distributing Clothes to the Poor.* By Domenichino, *c.* 1617. Rome, San Luigi dei Francesi. (Photo: G.F.N.)

40. Detail of 14.

41. *Peter and John Healing on the Steps of the Temple.* By Poussin, 1655. New York, Metropolitan Museum (Marquand Fund, 1924). (Photo: Museum.)

42. *The Holy Family on the Steps,* detail.

43. *The Holy Family with the Tub.* By Poussin, *c.* 1650. Cambridge, Mass., Fogg Art Museum, Harvard University (Gift of Mrs Samuel Sachs in memory of Mr Samuel Sachs). (Photo: Museum.)

44. Detail of 43.

45. Preparatory drawing for *The Holy Family on the Steps.* By Poussin, *c.* 1646. Pen and bistre wash. Dijon Museum. (Photo: Museum.)

46. Preparatory drawing for *The Holy Family on the Steps.* By Poussin, *c.* 1646. Pen and bistre wash. New York, Pierpont Morgan Library. (Photo: By courtesy of the Pierpont Morgan Library.)

47. Preparatory drawing for *The Holy Family on the Steps.* By Poussin, *c.* 1647. Pen. Paris, Musée du Louvre, Cabinet des Dessins. (Photo: Museum.)

48. Preparatory drawing for *The Holy Family on the Steps.* By Poussin, *c.* 1647. Pen and bistre wash over chalk. Paris, Musée du Louvre, Cabinet des Dessins. (Photo: Museum.)

49. Preparatory drawing for *The Holy Family under a Group of Trees.* By Poussin, *c.* 1650. Pen and bistre wash. Paris, Musée du Louvre, Cabinet des Dessins. (Photo: Museum.)

50. Preparatory drawing for *A Holy Family.* By Poussin, *c.* 1648. Pen and bistre wash. Paris, Musée du Louvre, Cabinet des Dessins. (Photo: Museum.)

51. *The Holy Family on the Steps,* detail. (Photo: Henry Beville.)

52. *Rebecca and Eliezer.* By Poussin, 1648. Paris, Musée du Louvre. (Photo: Villani, Bologna.)

53. *The Holy Family on the Steps*, detail.

54. *The Madonna della Scala*. By Andrea del Sarto, *c.* 1522. Madrid, Museo del Prado. (Photo: Museum.)

55. *The Madonna of the Stairs*. By Michelangelo, *c.* 1491? Florence, Casa Buonarroti. (Photo: Alinari.)

56. *The Holy Family with St Anne, St Elizabeth and John the Baptist*. By Poussin, 1649. Dublin, National Gallery of Ireland. (Photo: Museum.)

Index

Bold numbers refer to illustration numbers